IN LOVING MEMROY OF

Geordan Allen Farkas

PRESENTED BY

Norma Burlando (Aunt)

FINDING HOME

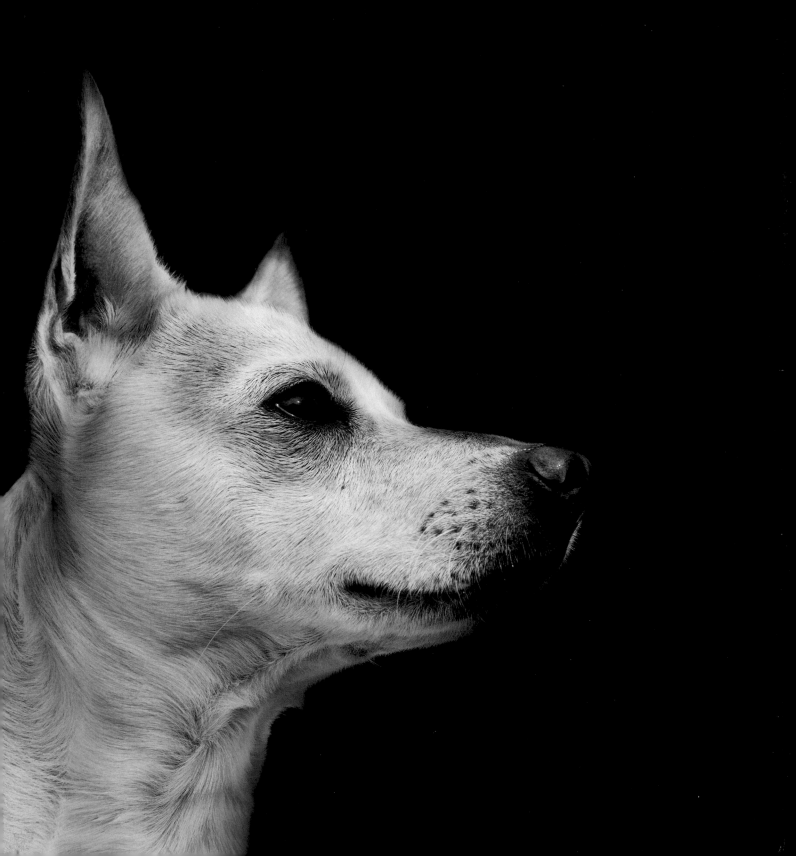

FINDING HOME

shelter dogs & their stories

Traer Scott

PRINCETON ARCHITECTURAL PRESS · NEW YORK

Published by
Princeton Architectural Press
37 East Seventh Street
New York, New York 10003

Visit our website at www.papress.com.

Editor: Sara E. Stemen
Designer: Mia Johnson

Special thanks to: Nicola Bednarek Brower, Janet Behning,
Erin Cain, Megan Carey, Carina Cha, Andrea Chlad, Tom Cho,
Barbara Darko, Benjamin English, Jan Cigliano Hartman,
Jan Haux, Lia Hunt, Diane Levinson, Jennifer Lippert, Jaime Nelson,
Rob Shaeffer, Marielle Suba, Kaymar Thomas, Paul Wagner,
Joseph Weston, and Janet Wong of Princeton Architectural Press
—Kevin C. Lippert, publisher

Library of Congress Cataloging-in-Publication Data

Scott, Traer.
Finding home: Shelter dogs and their stories / Traer Scott.
pages cm
ISBN 978-1-61689-343-9 (alk. paper)
1. Dogs—Anecdotes. 2. Dogs—Pictorial works.
3. Dog adoption—Anecdotes. I. Title.
SF426.2.S42 2015
636.7—dc23
 2014045183

Table of Contents

1

Introduction

7

Portraits & Stories

76

Biographies

85

Adoption Basics and Resources

88

Reflections on Animal Rescue

90

Acknowledgments

For my Cricket.
I look for you in every dog I meet.

INTRODUCTION

My 2006 book *Shelter Dogs* started off as a fragile thing, a project as pure and intuitive as its subjects. My editor and I truly didn't know if the world was ready to look all of those faces in the eye, but a nation of dog lovers soon responded with a resounding "yes." It received rave reviews and sold over fifty-thousand copies worldwide—far beyond expectations. The book raised tens of thousands of dollars for the American Society for the Prevention of Cruelty to Animals (ASPCA) and was even translated into Japanese.

The success of *Shelter Dogs* launched my career. So much has changed in my life since then. I traveled the world with a camera for several years; digital replaced film; I published five books; my darkroom became a nursery; I became a mom; my best friend of sixteen years died. But there are many more things that have not changed: I am still married to the man I love; I still live in the same terribly unfinished historic house; I still wish my hair were straighter; and I still marvel at how fortunate I am to do what I love every single day.

Unfortunately, for millions of dogs, nothing has changed.

In the past decade I have seen the desire to adopt, as well as knowledge about both the plight of homeless animals and the need to spay and neuter, increase dramatically, but still not enough. According to the ASPCA, over one million dogs are euthanized every year in US shelters. The good news is that almost one and a half million are adopted, and according to many sources, euthanasia rates are falling every year.

This new book presents a unique opportunity for both me and my readers to look back at the past decade and perhaps gauge our successes and failures in the greater animal welfare community—to take stock of where we are, compared to where we were ten years ago. That is one reason that I jumped at the suggestion of a sequel to the now out-of-print *Shelter Dogs*. In addition, with a decade more experience, I am more skilled at what I do. I have photographed hundreds, possibly thousands, of dogs all over the world. In this new effort, I hope to convey the same message in greater detail, with more heart and less sentiment.

Over the years, I have received an enormous number of comments, accolades, and criticisms about *Shelter Dogs*. I would like to discuss some of them because, for better or worse, they are just as relevant now as they were then.

Some folks felt that there was too much emphasis on pit bull rescue in the first book. I agree—there were way too many pit bulls in the first book. But that is because there are way too many pit bulls in shelters. I tried to represent accurately what was happening, which even now is little short of massacre. Every urban shelter in this country is overrun with pit bulls, and only a fraction of them find homes. There is an epidemic of neglect centered around this vilified yet popular breed, and despite efforts against breed-specific legislation, even with education and all of the pit bull advocacy in the world, there will *never* be enough homes for these dogs. As a shelter director recently told me,

"We help pit bulls because they are the dogs that need help right now."

Despite the immense success of *Shelter Dogs*, I sometimes wondered if I were preaching to the choir. It's true that a whole lot of people in the animal welfare community were really excited that for the first time ever, there was a book that helped put a voice to what they do. The photos spoke to them and reminded them of dogs they had helped and many that they had not been able to help. The text echoed their own struggles in rescue: the tear-filled nights, the determination and often desperation that they feel while taking on a ceaseless flow of animals in need. I am very proud to have created this touchstone.

The book also reached those who most needed to hear the message. I got dozens of emails from people who had always been dog lovers but decided after reading the book to take action and finally start to volunteer or to organize donations for their shelter or to add an adopted dog to their family of purebreds. The book also acted, as I hoped it would, as a cri de coeur, a call to action for animal lovers. One consumer reviewer told of how he bought twelve copies of the book and handed them out to his city council members to try to bring about change at their city's municipal shelter. There is no higher honor than knowing that your work has inspired people to action.

Occasionally people suggested that there was not enough text in *Shelter Dogs*. Had it been up to me, there would have been even less. I wanted you, the reader, to look at a face, connect with it, and then turn to the back of the book and be struck by that dog's fate. With this book, I wanted readers to experience a deeper connection with some of these dogs, to receive glimpses of their individual journeys and feel them come to life on the page even more. I also wanted to use these stories as a way to address many of the misconceptions, both positive and negative, about shelter dogs.

Readers may notice that only four out of thirty-five dogs in this book did not make it. This ratio does not represent the actual state of things. The ASPCA reports that 35 percent of dogs entering shelters are adopted, 31 percent are euthanized, and 26 percent of dogs who come in as strays are returned to owners. So by this formula, 11 (rounded up from 10.85) of the 35 dogs that I have featured in this book should have been euthanized. But they weren't. Why?

Many factors go into determining rates of adoption versus euthanasia: geographic location, breed, history, temperament, legislation, and many times just sheer dumb luck. A dog who goes out on walks might survive, whereas a dog who is constantly confined in a kennel might not. An average-looking dog who has a flattering photo posted on Facebook might get adopted, whereas a gorgeous dog who is only photographed cowering in a cage will not. On and on it goes, this cruel game of chance and human intervention.

Some shelters have a strict time limit, so no matter how adoptable the dog is, after a specified number of days it has to be euthanized. Fortunately, this is becoming more and more rare, but in some corners of our country, "animal control centers" are still just that. They are a way to contain and deal with stray or feral animals. They are pounds, relics of a different time when unwanted animals were electrocuted or gassed instead of humanely euthanized. In these places, priority is placed on protocol, not adoption or humane treatment.

The same highly adoptable dog who is snapped up in a few hours in a Massachusetts shelter might linger in a Kentucky shelter and end up being put to sleep. This scenario is extremely common and is what has sparked the massive animal transport phenomenon that is

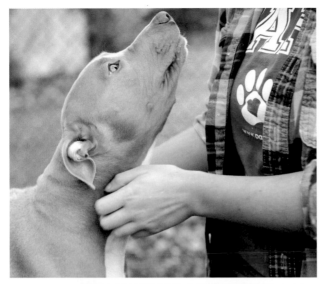

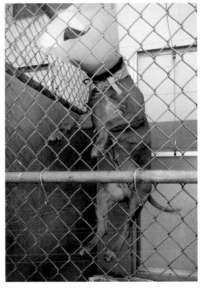

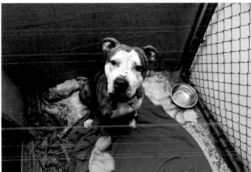

Clockwise from top left: Volunteers make a huge difference in shelters. Even with regular exercise, many dogs begin to exhibit signs of anxiety and distress when in their kennels; repeated jumping is a common behavior for stressed dogs. This is the space in which a shelter dog may spend many months.

so prevalent right now. Believe it or not, some cities and towns have so effectively educated their communities about the need for spaying and neutering and the virtues of adoption that their shelters are virtually empty, so they arrange transport from shelters in other parts of the country that are overwhelmed with dogs. Very often these imports are puppies, small breeds, and other types of dogs generally considered to be highly adoptable, but sometimes they are older dogs, sick dogs, or mother dogs whose pups were all adopted without a home being found for her.

There are differing views on transport. Many people feel that saving a life is saving a life, regardless of where that life originated. Others feel that rescue organizations should focus first (or solely) on the needs of the animals in their own community. I am generally inclined toward the idea that saving a life is good, regardless, but I find it very frustrating when shelters choose to import obviously adoptable dogs while ignoring less-adoptable dogs who are dying in their backyards.

Why would a shelter do this? It comes down to numbers. Many private shelters rely on their stats to raise funds. So when they tell their supporters that they have a 90 percent adoption rate or that they adopted out two thousand animals in the last year, those supporters feel that the money they're giving is working. When shelters

3

take in less-adoptable dogs (like pit bulls or senior dogs or sick dogs), their numbers are bound to be affected in a negative way. Many no-kill shelters refuse to take pit bulls and other less-adoptables for the same reason.

Ultimately, all rescue policies and politics aside, the reason that so many of the dogs in this book made it is because the shelters and rescue groups that I worked with on this book are highly effective.

The Providence Animal Rescue League (PARL) in Providence, Rhode Island, is a private shelter dealing with owner surrenders. It receives all manner of breeds, ages, and temperaments, but the overall surrender numbers have (happily) dropped, and the community is so eager to adopt what dogs they do have that very few stay in the shelter more than a few weeks. However, a few blocks over, the municipal shelter is constantly packed to capacity, so PARL frequently takes dogs from them. Sometimes it takes little dogs, seniors, or ones who need medical care or serious grooming, but generally, it takes pit bulls. At PARL these pits will get adopted, whereas at the municipal shelter, they would not. Why? PARL has the resources to exercise and train and provide care for these dogs. It has the staff to walk them, play with them, and provide them with enrichment activities involving training and mental stimulation, all of which make them happier and more adoptable. It also has a well-established reputation in the community. Everyone knows that if you're looking to adopt a dog, you go to PARL. Community outreach, branding, and word of mouth have built and informed this public opinion for decades.

On a personal note, PARL has always been highly supportive of my work, and my relationship with the shelter is one that I treasure. Over many months, it worked with me to photograph a wide swath of the dogs that it hosted in 2013 and 2014. Fund-raising manager Connie Bolduc and behavior coordinator Bethany Nassef worked particularly closely with me, making time in their schedules to wrangle for photo shoots, keeping meticulous records of the dogs we photographed and helping me to connect with the families who adopted many of the dogs.

North Kingstown Animal Control in North Kingstown, Rhode Island, is an example of a small municipal shelter that works for the animals as well as the community. It takes in dogs who are found as strays as well as owner surrenders. Animal control officer Holly Duffany is devoted to her job because she loves animals and truly wants to make a difference. She also has figured out the key to successfully moving dogs, which is networking. Partnering with other shelters and local rescue groups gives shelter workers emotional and logistical support within their community, as well as options for the animals in their care. The more insular a shelter becomes, the lower its effectiveness. Fortunately, North Kingstown has been able to work with Handsome Dan's Rescue, one of the most notable rescue groups in the country.

Handsome Dan's Rescue was built around the eponymous Vicktory Dog and notorious snuggler, Handsome Dan. (Vicktory Dogs were the survivors of abuse at the hands of NFL quarterback Michael Vick and his co-owners in an illegal dogfighting operation.) HDR doesn't have a physical shelter; it is a network and rescue resource that works with many shelters to help place pit bull–type dogs who are in danger of being euthanized in other shelters. These dogs are often pulled and transferred to shelters with more resources or placed in foster homes. HDR is also dedicated to providing enrichment for dogs who are having a difficult time with shelter life. It has a dozen enrichment volunteers (and a long list of hopeful applicants) who are assigned a particular shelter dog in desperate need of socialization and training.

The volunteer visits the dog several times a week in the shelter to work on basic obedience. Volunteers also take dogs out into the community, where they will be visible to the public while gaining valuable socialization skills. Crowds, children, loud noises, people of various ethnicities, and even people wearing hats are all useful for a dog to encounter. Enrichment volunteers also take their dogs to a special training course called Pits and Pals C.L.A.S.S. every weekend. C.L.A.S.S. stands for "canine life and social skills" and is a six-session course that is open to the public and taught by Handsome Dan's founder, Heather Gutshall. Attendees are a mix of shelter enrichment dogs, owned dogs, and some dogs who have been recently adopted. Most are pit bulls. The course teaches real-life skills, not party tricks or a laundry list of commands. Pit C.L.A.S.S., like Handsome Dan's in general, is all about hands-on change. As with any true grassroots effort, that change is first experienced on a micro level—in this case, by one dog at a time in the New England area. But with an immense social-media following, HDR is also able to inspire and involve a vast national and international audience on a daily basis.

The fourth group that I worked with, Fast Friends, is also dedicated to helping a specific group of dogs in need: greyhounds. Located in the college town of Keene, New Hampshire, Fast Friends works with racetracks and rescue groups around the country to help place former racing greyhounds and educate the public about dog racing.

I have a new tradition: every summer I take a quick trip up to Keene and spend a day in the country, photographing dogs for the Fast Friends annual fund-raising calendar. Animal-welfare advocate Marylou Hecht designs the calendar and is also a tireless supporter of Spanish galgo rescue. This time around, I wanted to include a few greyhounds in my book; although you probably won't come across one of these quiet giants in your local shelter, many, many former racers are in need of homes.

Although commercial dog racing is now outlawed in thirty-nine states, it remains legal and very active in seven states, including Florida, Texas, and Iowa. Much of the American public has finally become outraged by this cruel sport. Since 2001 the dog racing industry in the United States has been cut in half, but until it is completely abolished, dogs will continue to suffer.

So where does all of this leave us, as a culture of dog lovers? In my opinion, we are making progress. Those who care, care very loudly and with great passion. Many people who previously didn't know about these issues have now been made aware. As far as those who do not care at all, they probably never will, and the best that we can hope for is that they will simply stop contributing to the problem. Unfortunately, they are the bulk of the problem.

So while we should absolutely work to save the dogs who are right here right now, we should also think about how we can make truly lasting change. By supporting humane legislation, we will put laws in place to regulate and punish those people who will never care, and through community outreach and targeted humane education, we can reach new generations and create a future of people who do care.

Take heart: it *is* working. Though the change is often imperceptible to those who work day after day and year after year to save a seemingly endless flood of animals in need, we have made massive progress in the past forty years. In 1970 we were euthanizing approximately fifteen million animals a year in this country. Imagine. With continued activism and education, we could theoretically see the end of the pet overpopulation tragedy in our lifetime.

portraits & stories

BINGLEY

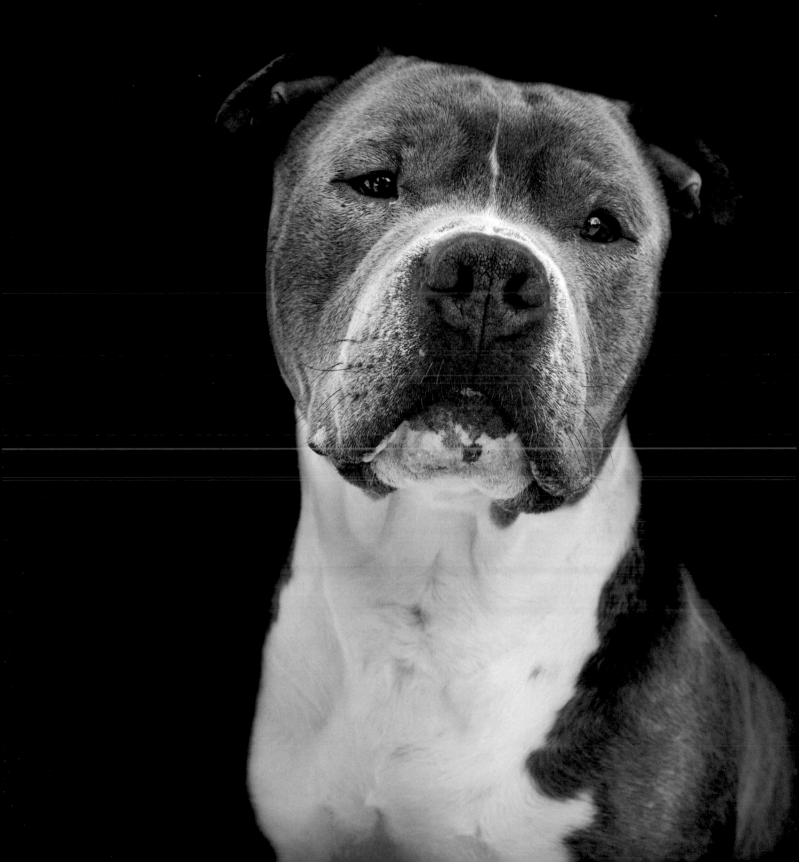

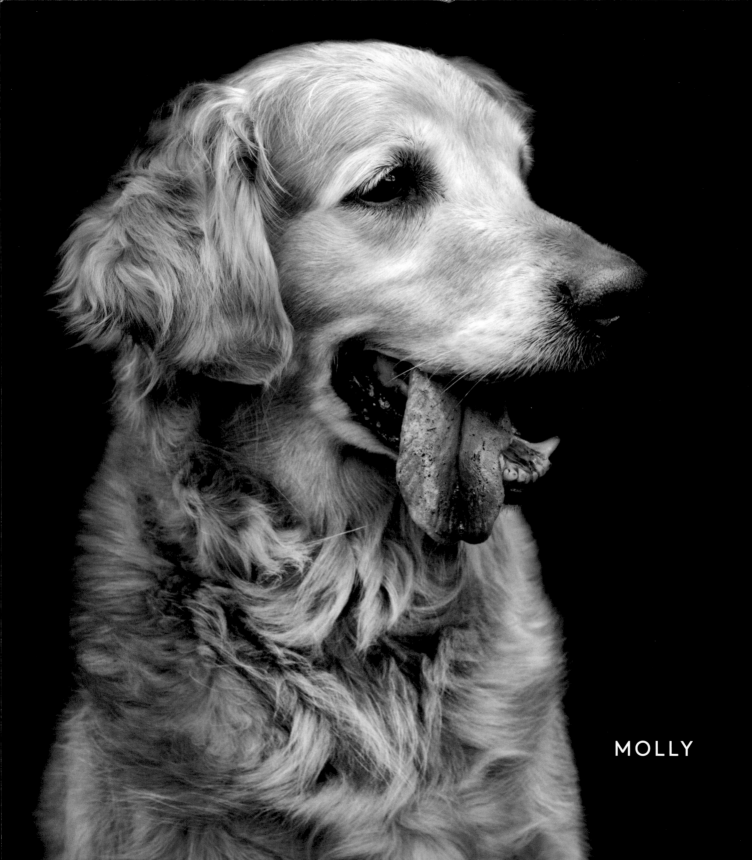

MOLLY

*It's always particularly heartbreaking to see
senior dogs in shelters; they seem
so bewildered and lost. Most have spent
their whole lives with one person or
family and then find themselves uprooted at
a point in their lives when change
is exceptionally difficult. Fortunately,
Molly was able to find a loving home with
a family who adored her.*

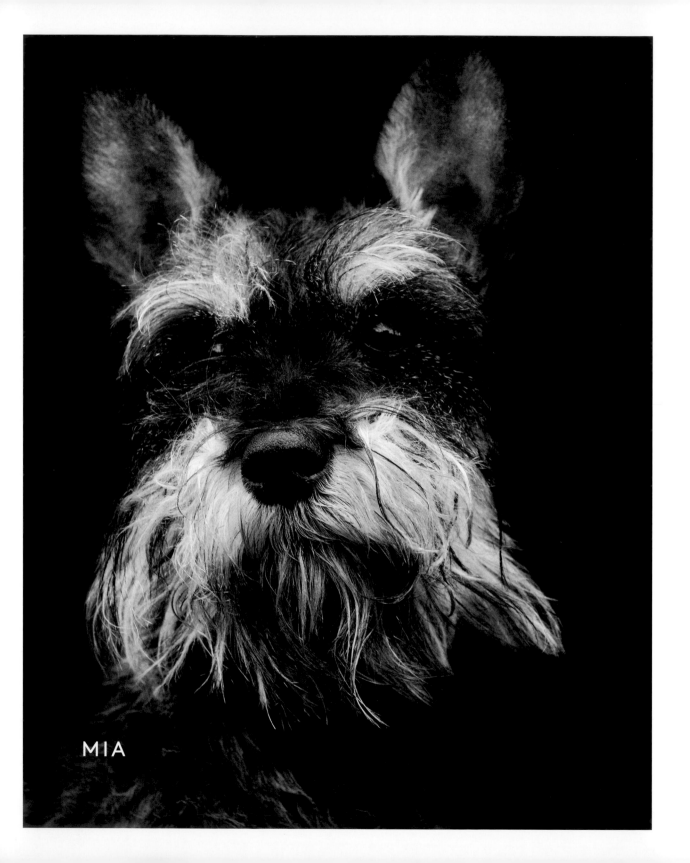

MIA

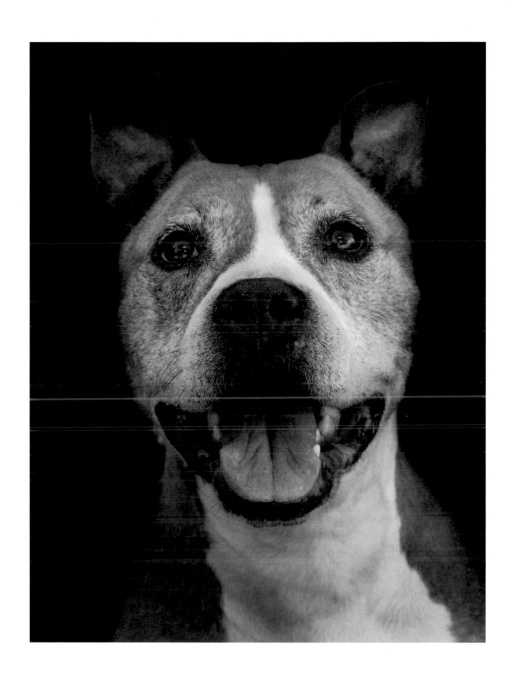

MATILDA

LAYLA

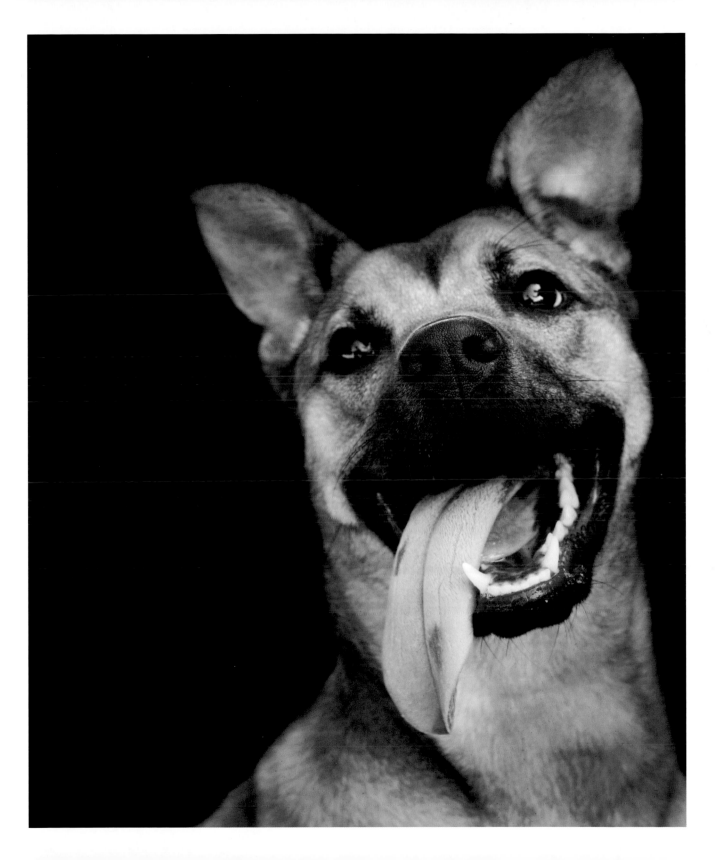

Layla's Story

There is a common misconception that all shelter dogs have been abused or mistreated, but that is by no means the case. Dogs end up in shelters for all kinds of reasons. Many come from loving homes, from good people to whom something bad has happened. Layla is a perfect example of this.

Layla was surrendered to the shelter after her family fell on very difficult financial times and lost their house. At the time of her surrender she was nine months old, spayed, fully vaccinated, and housebroken—quite a rare combination in a shelter dog. Her family was heartbroken that they had to give her up.

The shelter expected young, intelligent Layla to be snapped up immediately, but despite lots of initial interest from potential adopters, no one followed through. Finally, after two weeks, a young couple came to meet Layla and couldn't believe their luck. They went home after the initial meet and greet to think it over, but were worried all night that they would lose her to another adopter, so first thing in the morning, they rushed over to the shelter to finalize the adoption.

When Layla came home to their condo in a quiet, urban neighborhood, the first thing she did was poop on the rug. This is a pretty common reaction by dogs to unfamiliar environments. But that was the last accident she had in the house. Three weeks later she is a new regular at the local dog park and goes for runs with her "dad," who works from home, which has helped to ease Layla's transition and the innate separation anxiety that most shelter dogs experience.

The transition from having no dogs to having one dog is a big one, and no matter how prepared you are, it can be tough. Even armed with breed and behavior knowledge and all of the necessary gear, new owners find it takes a while to adjust to having another being in their house, particularly one who has so many needs.

Layla was surrendered to the shelter after her family fell on very difficult financial times.

A shelter dog, even without having been abused or physically harmed, has been through a lot emotionally. Abandonment causes fear of more abandonment, and living in a shelter, even the most modern and humane of places, means isolation, confinement, loud noises, strange smells, different food, and a complete shift in what is normal. Even the calmest, most easygoing dogs are disoriented in shelters. The good news is that most dogs adapt pretty fast to positive change and tend to settle into a new home within weeks.

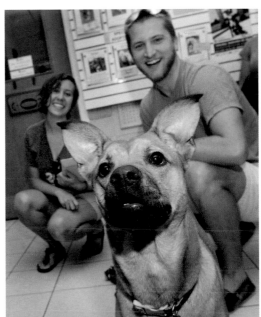

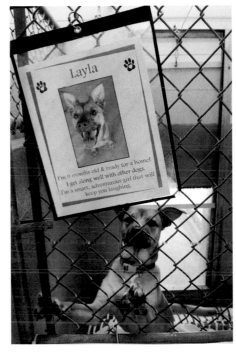

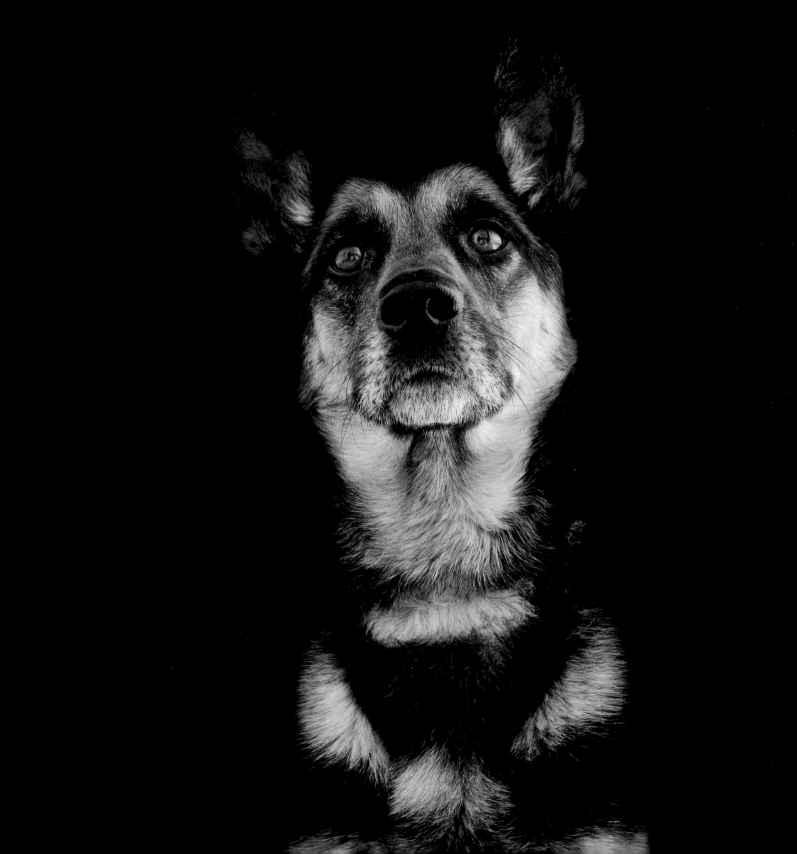

SOPHIA

CHEWY

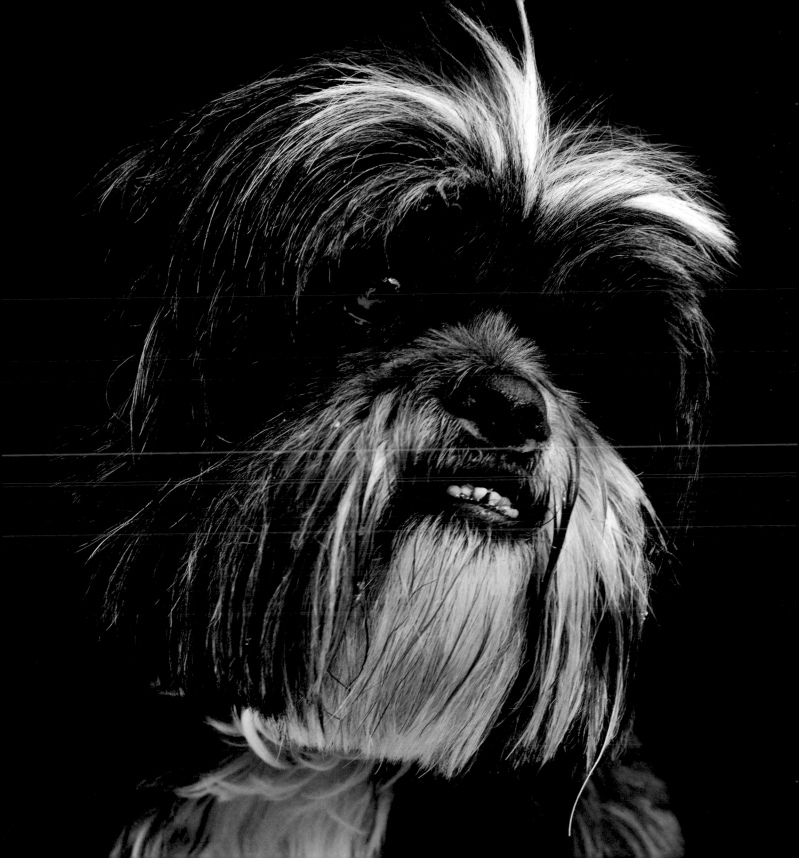

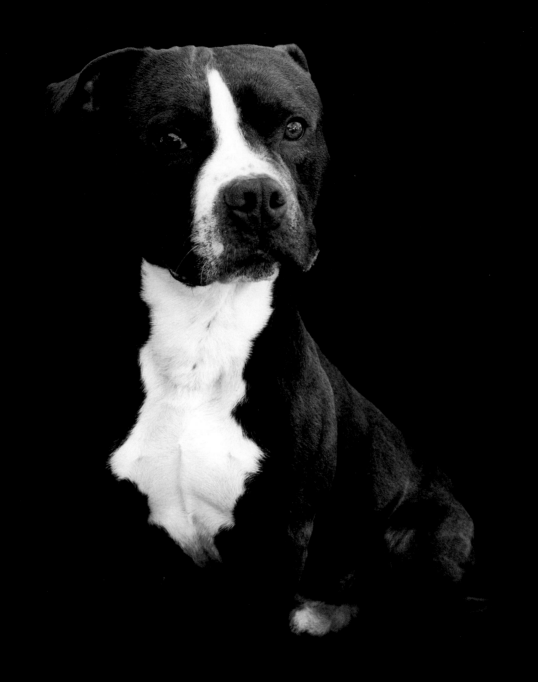

PYGMALION

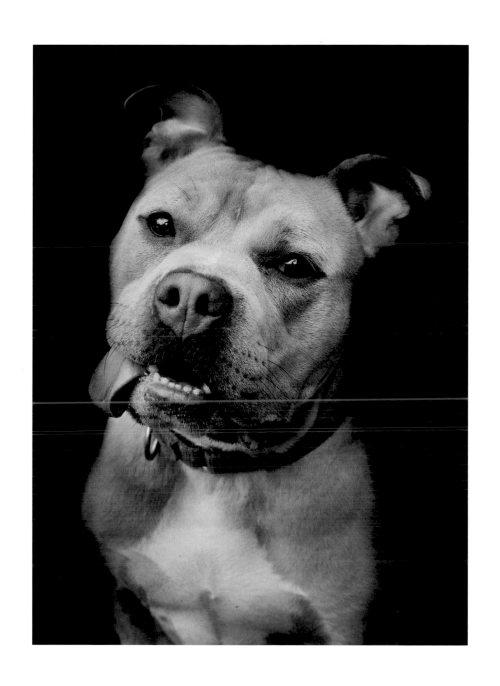

TEDDY

Noble and handsome, Cody had a bouncy, regal charm. Greyhounds move with such grace and yet play with the same good-humored ferocity and determination as other dogs. It's a beautiful spectacle.

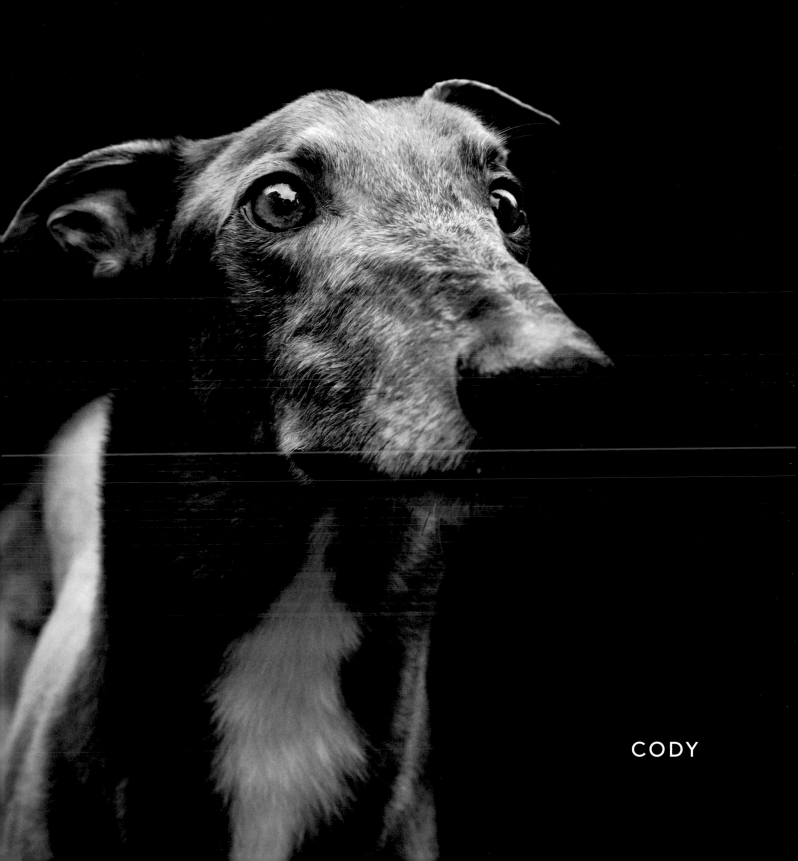

CODY

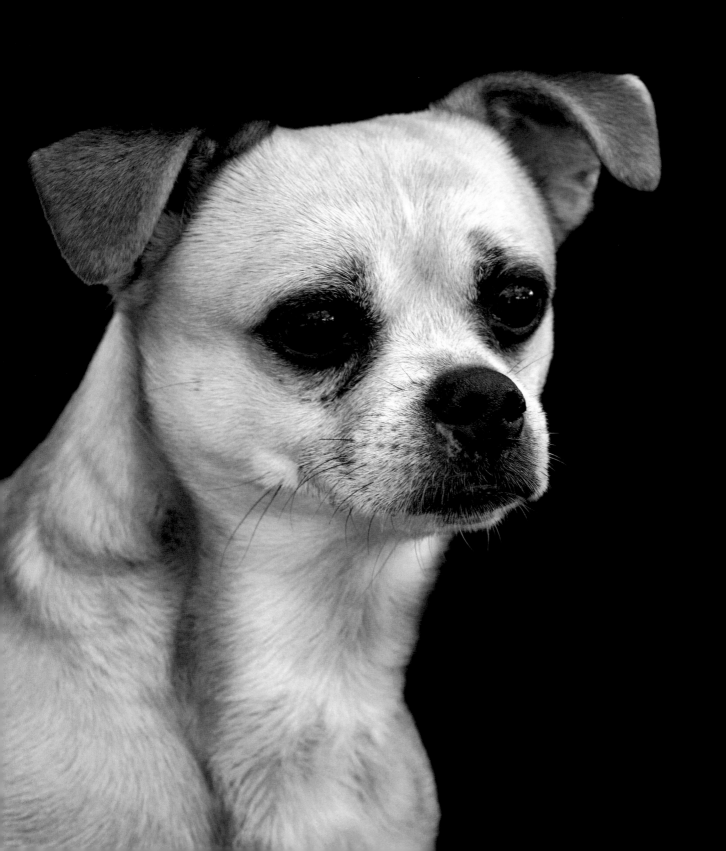

LUIGI

HOPE

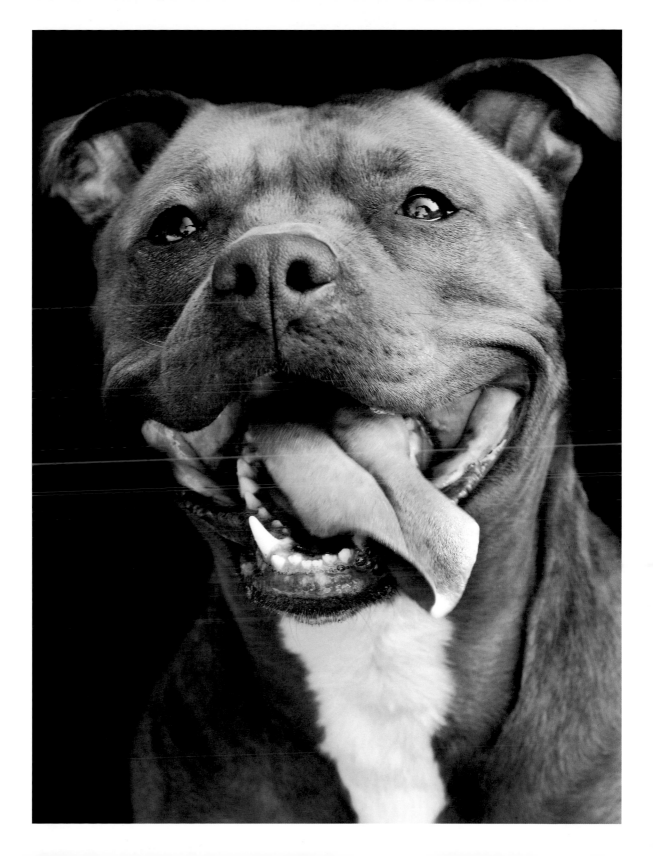

Hope's Story

Every shelter dog has a story, but some have epic tales. Hope is one of those dogs. Her life has been defined several times over by both human failure and redemption, as she has not once, but twice, escaped euthanasia in a shelter.

Her story as we know it began about three years ago at Manhattan Animal Care and Control shelter, where she had been turned in. All we know about Hope's life up to that point is that she was born with several physical deformities, including a badly misshapen back and hind legs. ACC in New York City receives thousands of dogs every year; space is very limited, and a dog like Hope—untrained, unsocialized, and malformed—doesn't stand a good chance. She was scheduled to be euthanized, but just hours before the appointed time, she was adopted and brought to Rhode Island.

Hope was adored by her new "mom," a single woman with disabilities who spoiled her with treats, plush beds, and doggie dresses. She even had her own Facebook page. For several years Hope lived a pampered life, but her troubles were far from over. In the summer of 2014, Hope's owner was suddenly hospitalized with life-threatening health issues. She lived alone and had no family to help care for her dogs (pitty Asher had also been adopted from Manhattan ACC), so they were taken into custody indefinitely by local animal control. Meanwhile, citing the owner's poor health and potential inability to care for the dogs, her landlord threatened to evict her if she did not rehome them. A decision was

made to transfer the dogs to a private shelter, where they could be nurtured and eventually adopted into new homes.

Asher got adopted after about a month, but Hope lingered. Her physical deformities caused her pain, and she hated being in her kennel. Despite this, her story and her struggle made her a staff favorite. The shelter staff and volunteers allotted a disproportionate amount of time to enrichment, training, and socialization for Hope, with the goal of helping her to ease her anxiety while increasing her adoptability. All the while, her owner kept in touch and sent care packages.

After several months, despite constant effort, attention, and care by the staff, Hope's condition deteriorated. She had become completely "kennel crazy" (a constant state of panic and exhaustion characterized by spinning, barking, jumping, crying, and sometimes self-mutilation), and her behavioral problems had increased rather than decreased, making placement with kids or other dogs impossible. Hope was not going to be adopted. The shelter decided that it was inhumane to keep her any longer, and Hope was scheduled to be euthanized. Again.

The dog coordinator, who had been there for Hope from the day she was surrendered, called her former owner to tell her the bad news. The woman was devastated and couldn't bear that Hope should be put to sleep, so she decided that she would bring her home, even if it meant losing her home. Since she was unable

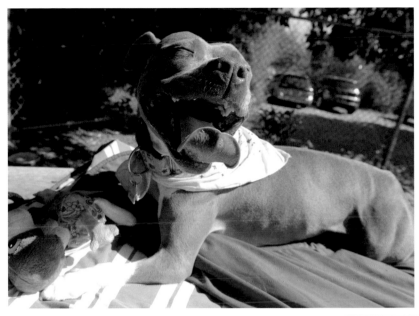

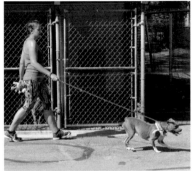

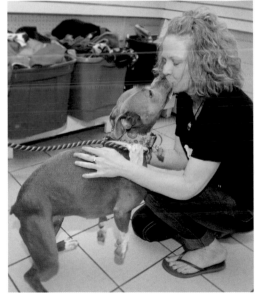

to drive, the shelter staff provided two-way transport. The reunion between dog and owner was tearful and extremely moving. The pure happiness that dogs can exhibit when they are reunited with their person is unlike anything else in the world, and she was obviously Hope's one true person.

Days later Hope's owner was evicted. Through the help of a crowdfunding campaign, she was able to raise enough money to cover moving expenses and find a suitable apartment that would welcome both her and Hope. At the time of publication, they had just settled into their new apartment, and Hope was once again donning frilly dresses.

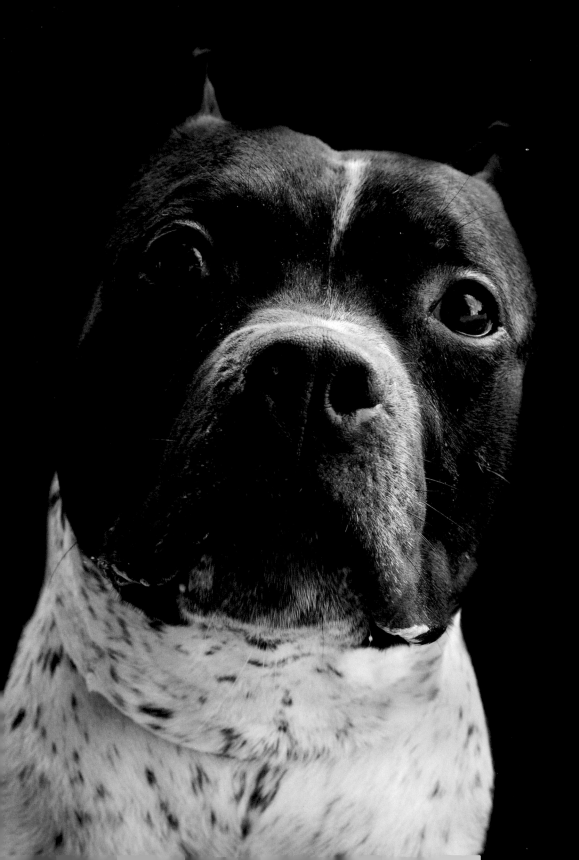

JUSTICE

Justice was one of those dogs who volunteers
secretly think will never make it out.
His closely cropped ears, muscular build,
and nervousness led him to be continually
overlooked, but in the end he did make it out—and
made a family very happy.

NANOOK

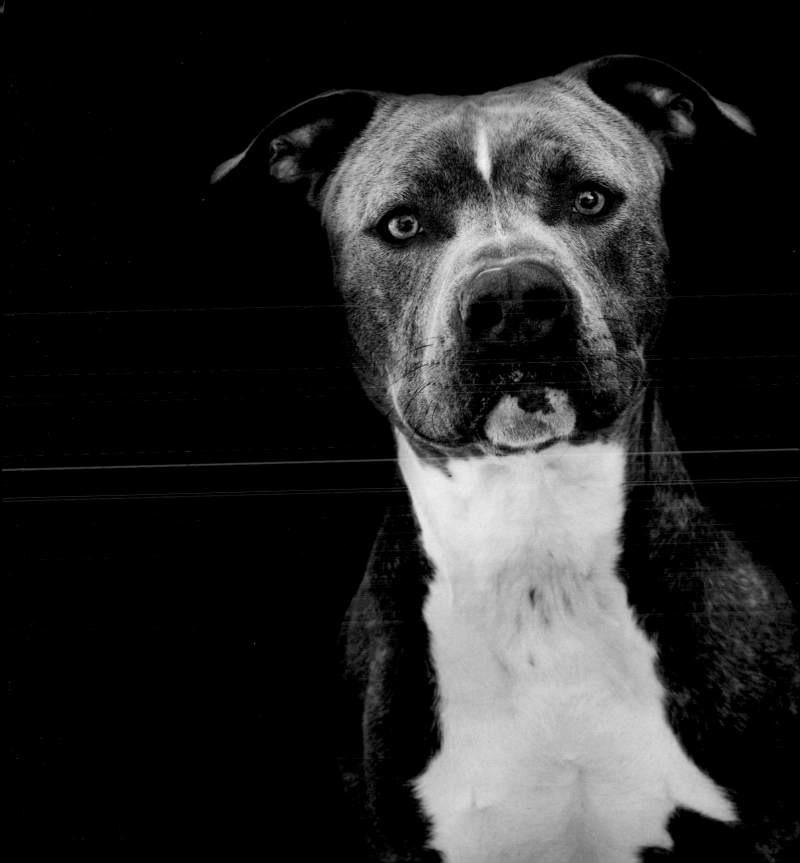

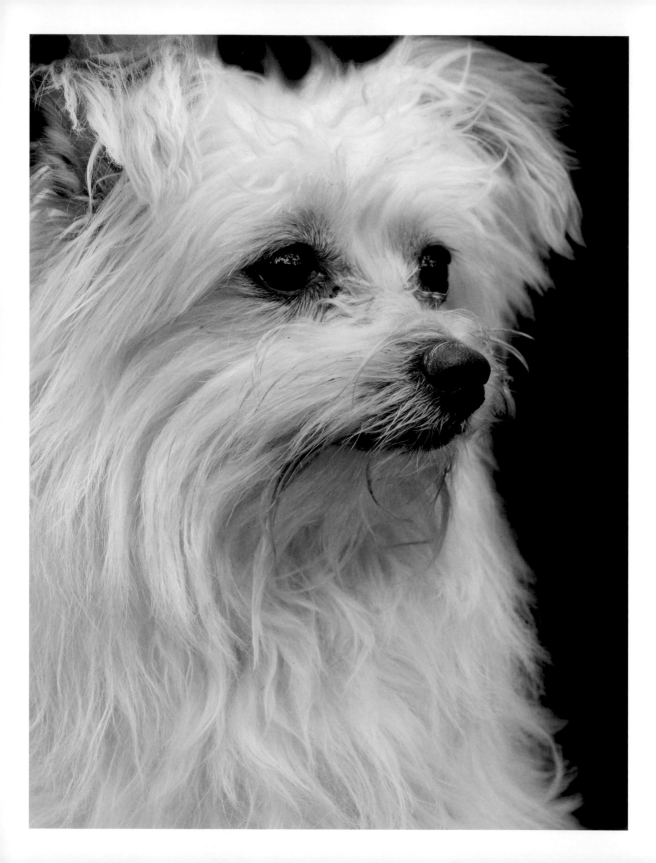

MUFFY VANDERBEER

MORRISSEY

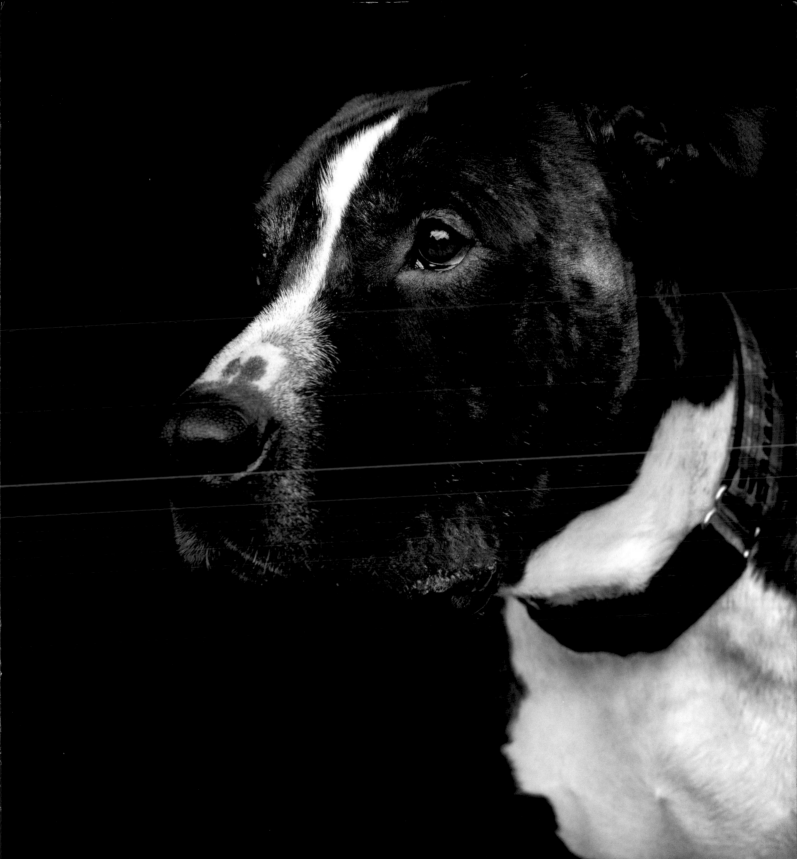

Morrissey's Story

At less than one year old, Morrissey was picked up as a stray and brought to the Providence animal control shelter, where he lingered for months. Soon, what appeared to be a minor case of mange became a full-blown problem due to the stress of being in a shelter. It spread across his entire body, leaving large patches of scaly, hairless skin. He began to show signs of being kennel crazy. (Usually, this severe anxiety is brought on by lack of exercise, inability to go to the bathroom outside, or simply by constant confinement. It is an extremely common problem for dogs in shelters, and many do not recover from it.)

> *What appeared to be a minor case of mange became a full-blown problem due to the stress of being in a shelter.*

Fortunately, Morrissey caught the eye of volunteers and was transferred to a private shelter where he could receive treatment for the mange, as well as more exercise and much more personalized attention. He began attending Handsome Dan's Rescue Pits and Pals C.L.A.S.S. with a shelter enrichment volunteer. He shone in the class and learned basic obedience and socialization skills. Once a week a volunteer would also take him to her office so that he could be exposed to different kinds of people, noises, and places.

At first it was unclear whether it was mange that was causing the hair loss. A skin scrape (the standard test for mange) came out negative, so staff began basic treatment with medicated baths. He did not get worse but did not get better, either. Later the shelter had his skin biopsied and found that the mange was so deep and severe that it had simply not shown up in the superficial skin scrape. Handsome Dan's Rescue raised funds for the expensive treatment that his skin would require.

Two months after he arrived at the second shelter, a family came in looking for a canine companion for the sixteen-year-old daughter. They were not looking for a pit bull and, in fact, were somewhat wary of the breed, but nonetheless, they fell in love with Morrissey. Morrissey went home and quickly bonded with his new family, which includes four children aged nine to sixteen, one of whom is disabled. He sleeps in bed with the sixteen-year-old, watches TV on the couch, and has a big bin of toys to play with.

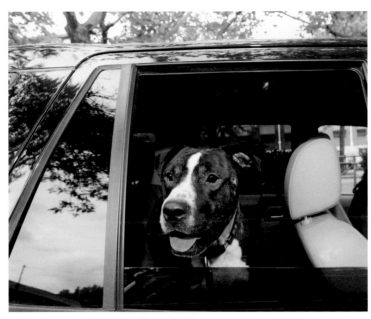

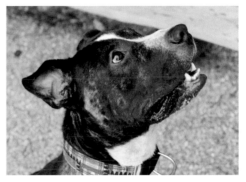

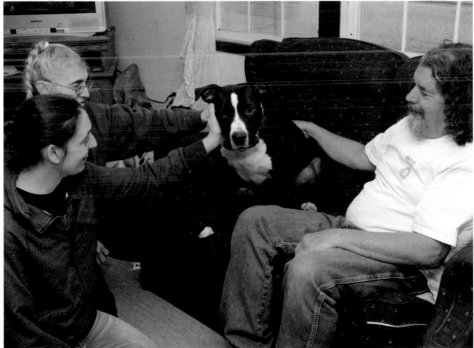

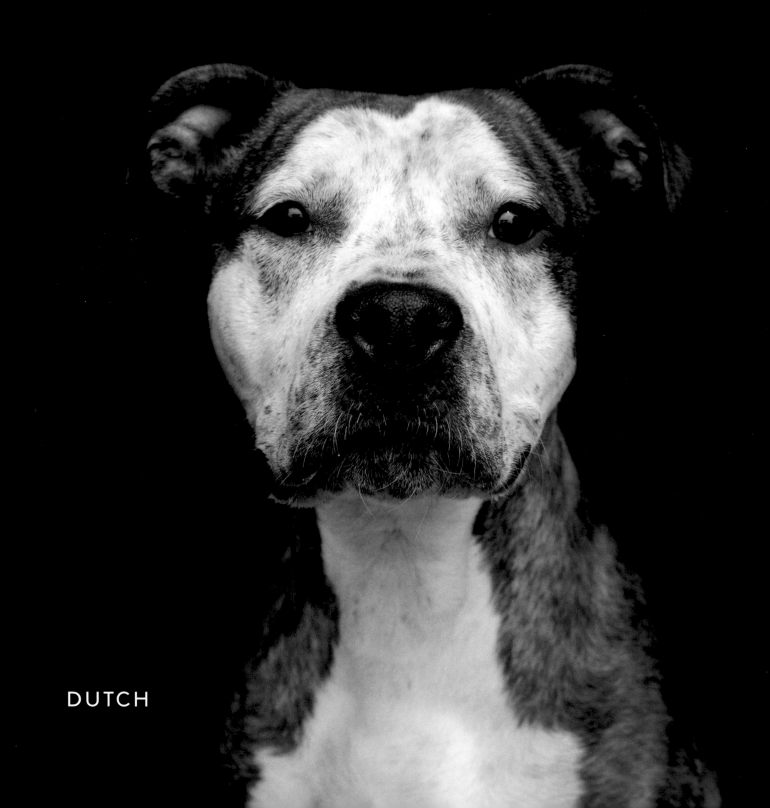

DUTCH

Dutch was one of the "oracles." These are the dogs who hold you in their gaze and don't let go. They lock eyes with you and silently impart what feels like the wisdom of centuries.

SALT

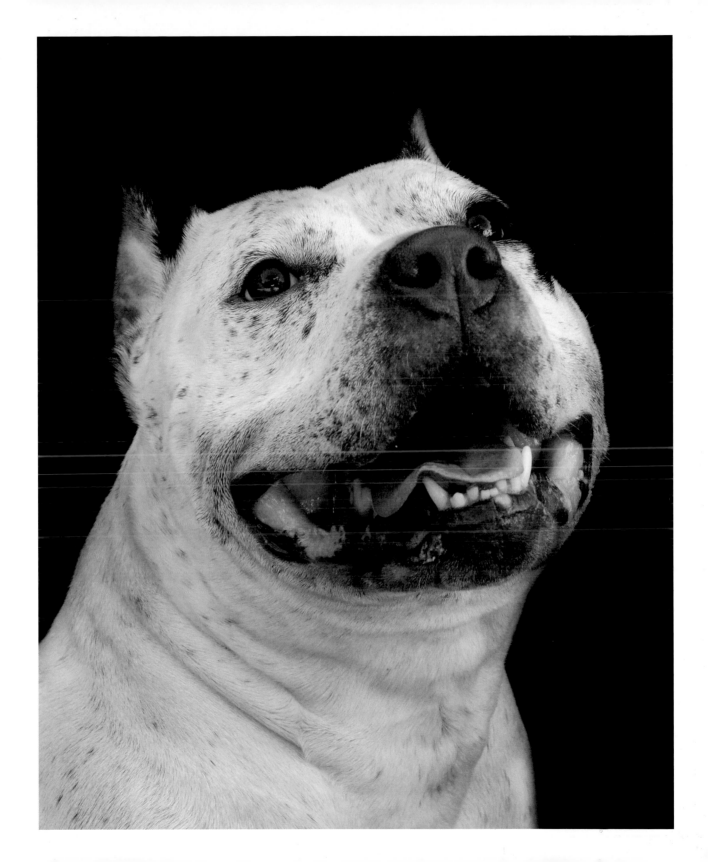

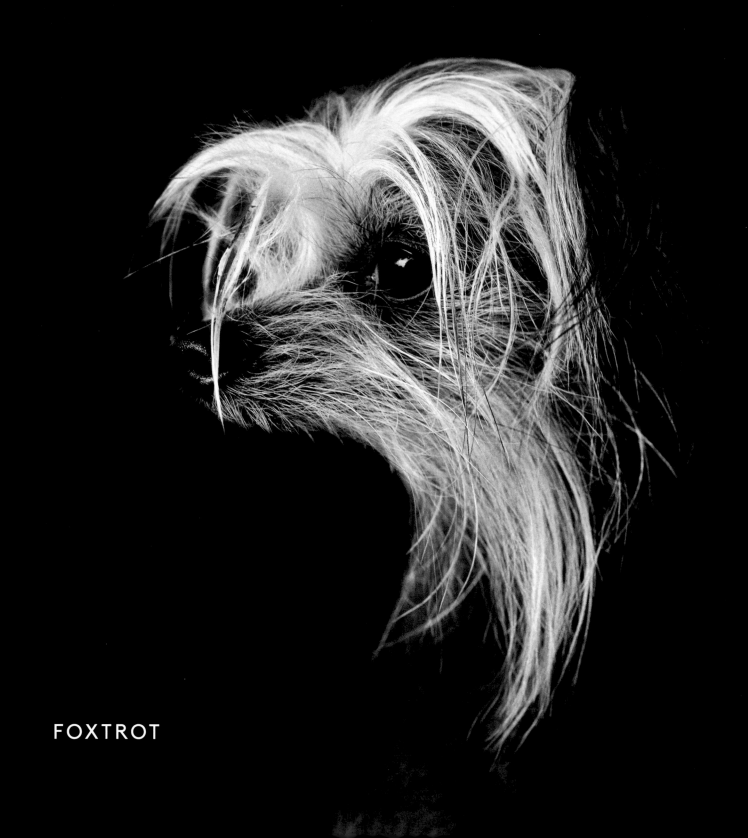

FOXTROT

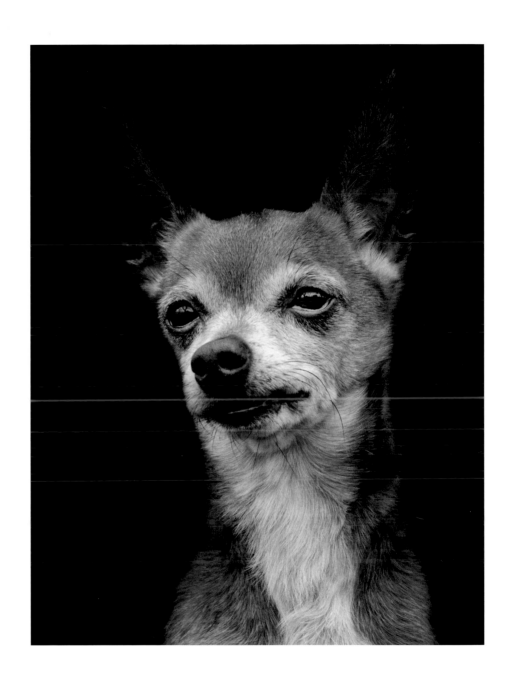

REMY

ROMAN

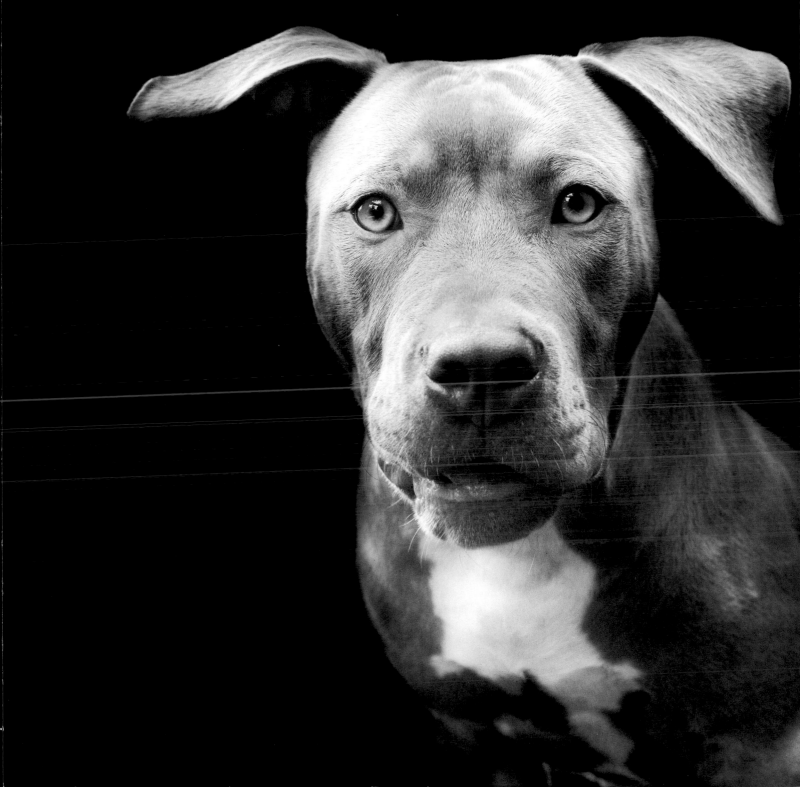

Roman's Story

Roman was bought from a backyard breeder by a family who already had one dog. The family's landlord soon decided that he didn't want a second dog on the property, and so Roman was surrendered to a shelter at six months old. An exceptionally large and lovely Weimaraner/pit bull–mix puppy, he won hearts immediately and was adopted quickly into the home of a young couple who adored him.

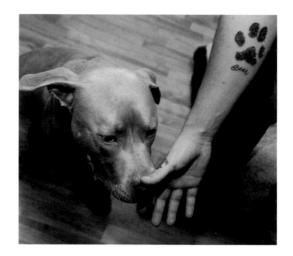

Just three months after Roman (rechristened "Bear") was adopted, he began limping on one of his front legs. Two trips to the vet revealed that he had a bone deformity that would require several costly surgeries. Soon after this diagnosis, Bear began to exhibit trouble breathing and lost his appetite. Further investigation showed a diaphragmatic hernia—not uncommon for his breed, but requiring yet another surgery. The couple began a GoFundMe campaign to help pay for the mounting vet bills and future surgeries, but soon after, closer examination of x-rays revealed an enlarged heart as well. Bear was diagnosed with congestive heart failure and given less than six months to live. Nothing could be done except to provide him with medicine to make him more comfortable.

This news was devastating to Bear's family, who had thought that they would be sharing the next decade of their lives with their adopted dog. Tragically, just weeks later Bear was euthanized to end his suffering.

Many people express concerns about adopting, based on cases like Bear's. Adopting a dog from a shelter is a risk—there's no doubt about that. In most cases, the new owner does not know the dog's health history or anything about his bloodline; however, no animal, even one from a respectable breeder, comes with a warranty.

Bear's family was happy to be able to provide a loving home for whatever time he had left. Dogs do not ponder their own mortality or mark the passage of time; they live very much in the now. Bear's family believes that he had no reason to feel as if he had anything less than a full life.

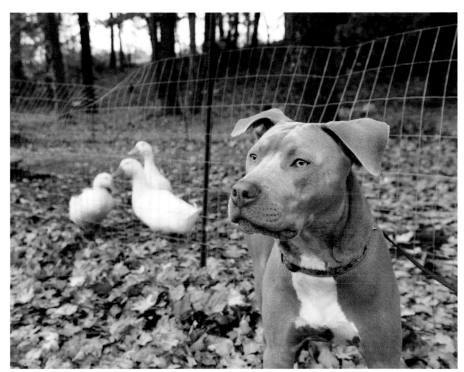

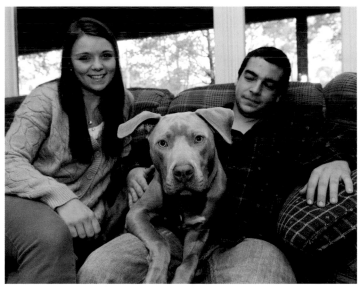

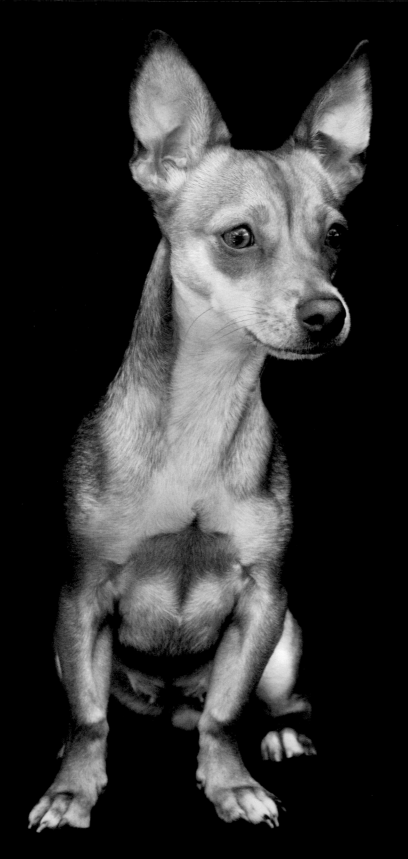

JADE

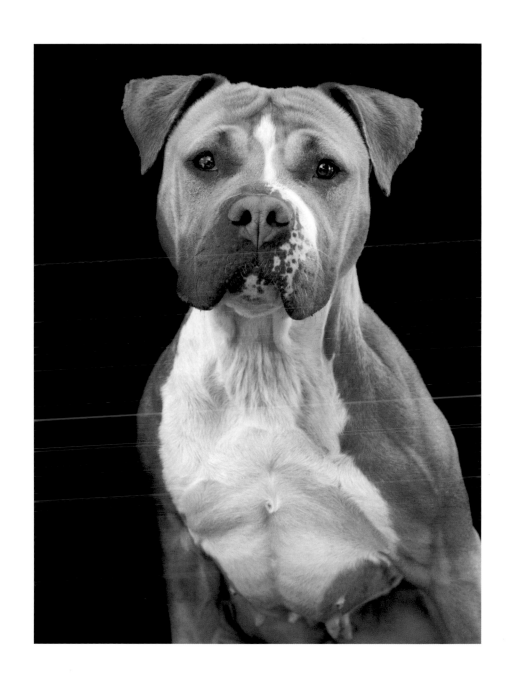

LORNA

GABRIEL

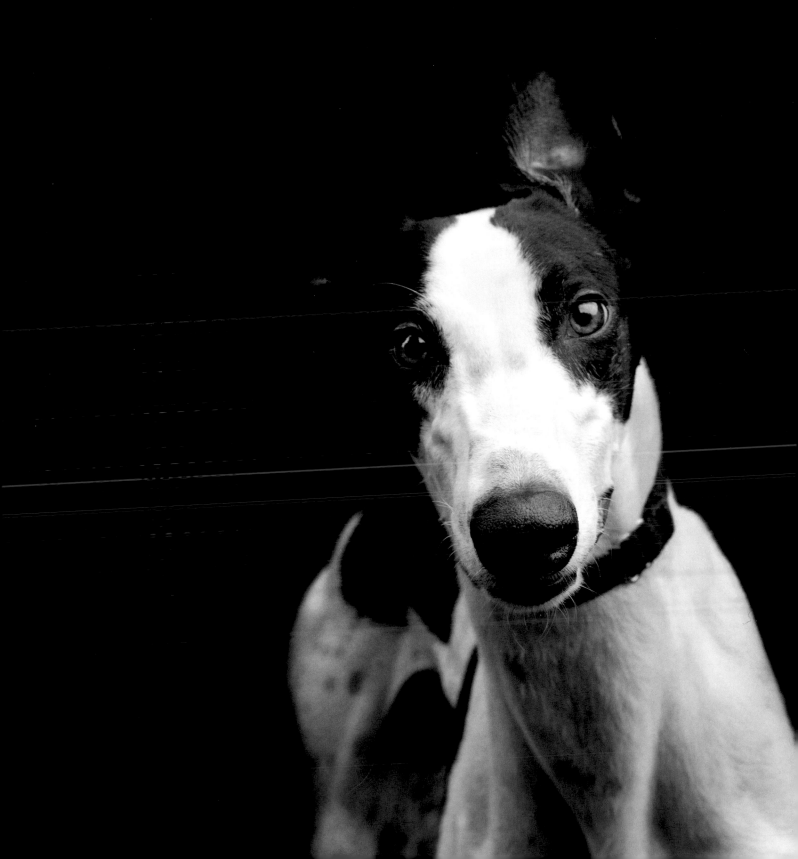

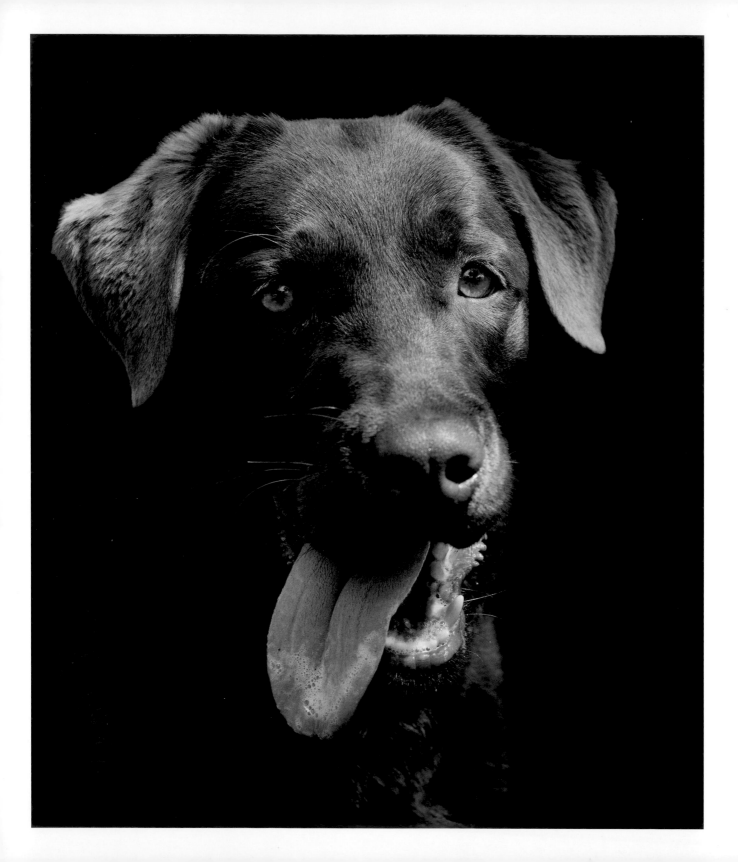

CHLOE

Lady was aptly named, for she was elegant
and kind, desiring nothing more from life than
sincere affection—and tennis balls.

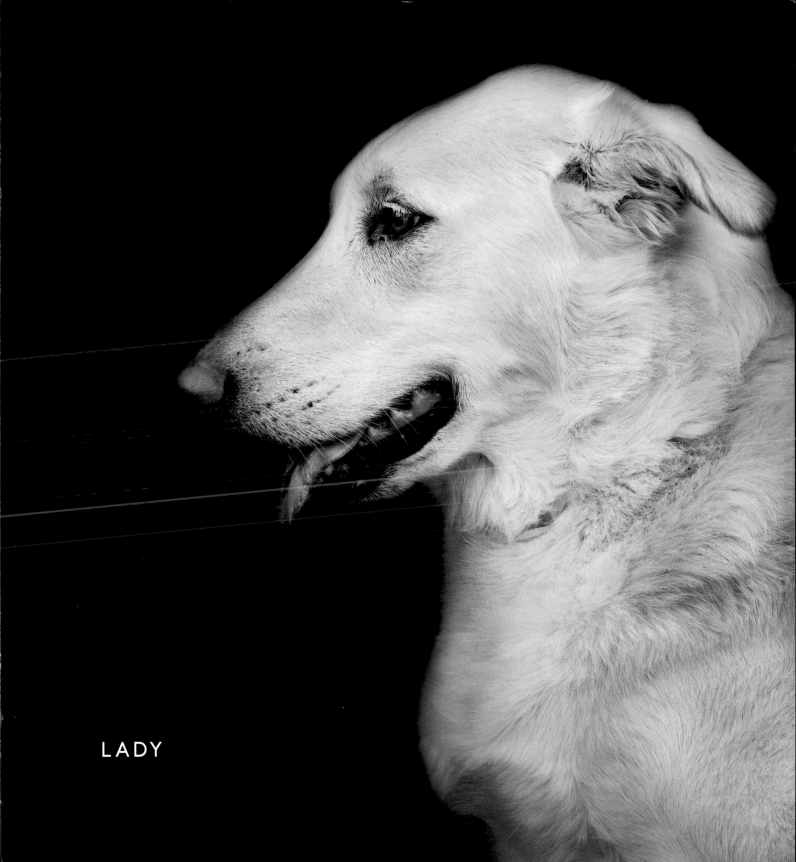

LADY

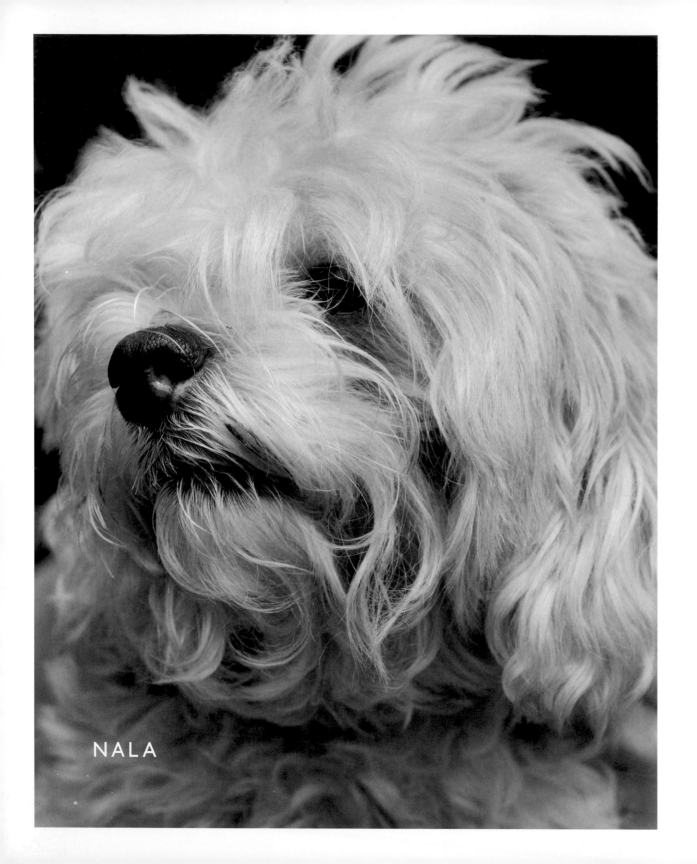

NALA

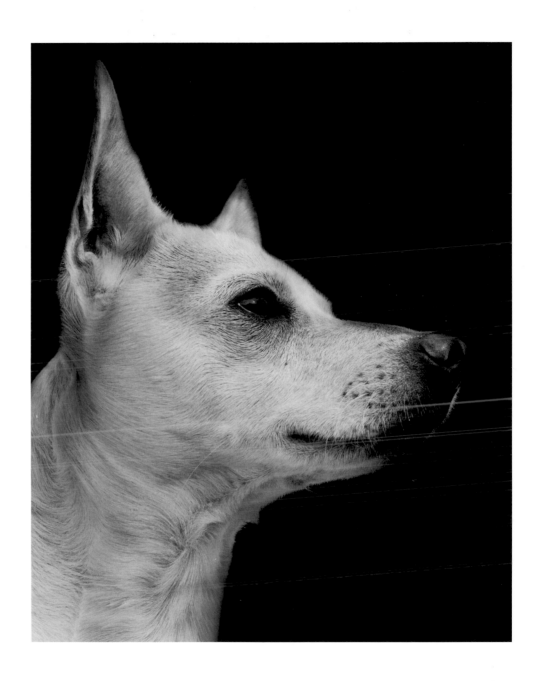

ELVIS

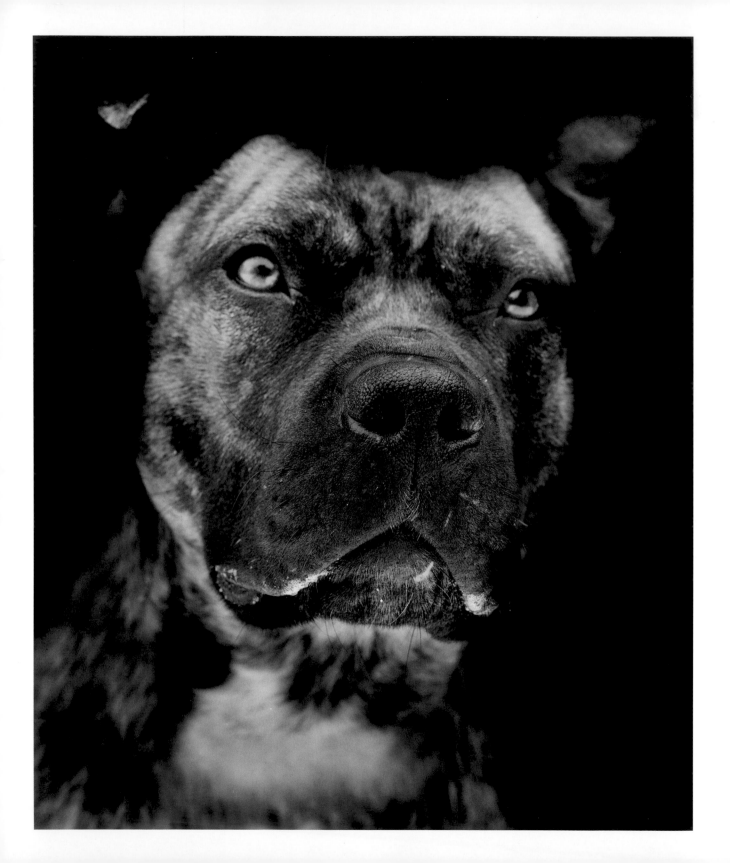

VINNY

Vinny's Story

Vinny was found as a stray behind Electric Boat, a submarine design and construction company in North Kingstown, Rhode Island. He was young and healthy, exhibiting an ideal weight, clipped toenails, and clean fur, so the North Kingstown Animal Control staff hoped that he had just gotten separated from his owner and would soon be claimed. Sadly, weeks went by, and no owner came forward.

Despite his goofy and fun demeanor, Vinny seemed intimidating to many people, due to his stocky, muscular build and large, broad head, which are characteristic of pit bulls. As with so many young, energetic dogs, Vinny's mental state began to deteriorate quickly in the shelter environment. He started to become aggressive to other dogs and had to be kept in an isolation kennel to avoid contact or chance encounters with them. There, he continued to receive attention and affection from staff and volunteers, as well as walks and lots of time outside in the shelter's enormous, fenced-in yard. The shelter staff and volunteers adored him, but no one wanted to adopt Vinny.

Many aspects of shelter life can be stressful or detrimental to an animal. The most obvious is confinement, but many other things, such as harsh smells, unfamiliar or repetitive sounds, and even new food, can contribute greatly to an animal's anxiety. In order to help Vinny to remain mentally and physically fit during his time in the shelter, he was taken to several sessions of Pits and Pals C.L.A.S.S. with a Handsome Dan's Rescue enrichment volunteer. He loved the weekly class, where he eagerly performed all of the tasks in exchange for treats and affection. With a forty-five-minute drive each way from the shelter to class and back, Saturdays were a day out for him. This provided a vital break from kennel and shelter life, plus Vinny was exposed to new people and places, thus improving his social skills and thereby his chances for adoption.

Despite his goofy and fun demeanor, Vinny seemed intimidating to many people, due to his stocky, muscular build.

Months went by. Countless internet posts from staff and volunteers pleaded for someone to fall in love with Vinny. His photos garnered hundreds of likes and shares on social media, but still no one showed interest in adopting him. His anxiety continued to grow, and after six months he was exhibiting signs of almost constant panic, both in and out of the kennel. Finally, just when staff were losing hope of a happy ending for Vinny, he was adopted by a local police officer and finally found the loving home that had eluded him for so long.

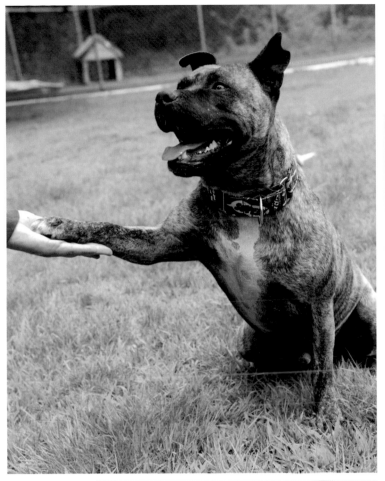

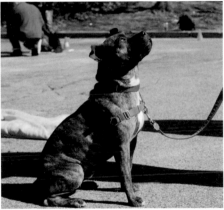

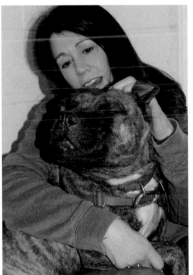

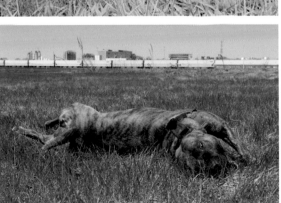

BANDIT

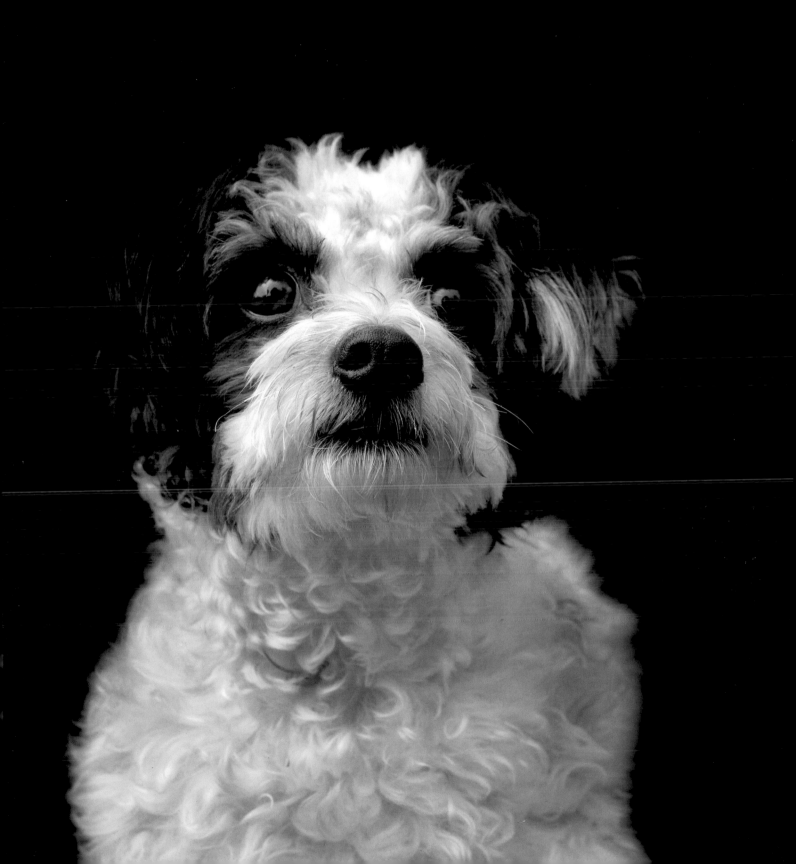

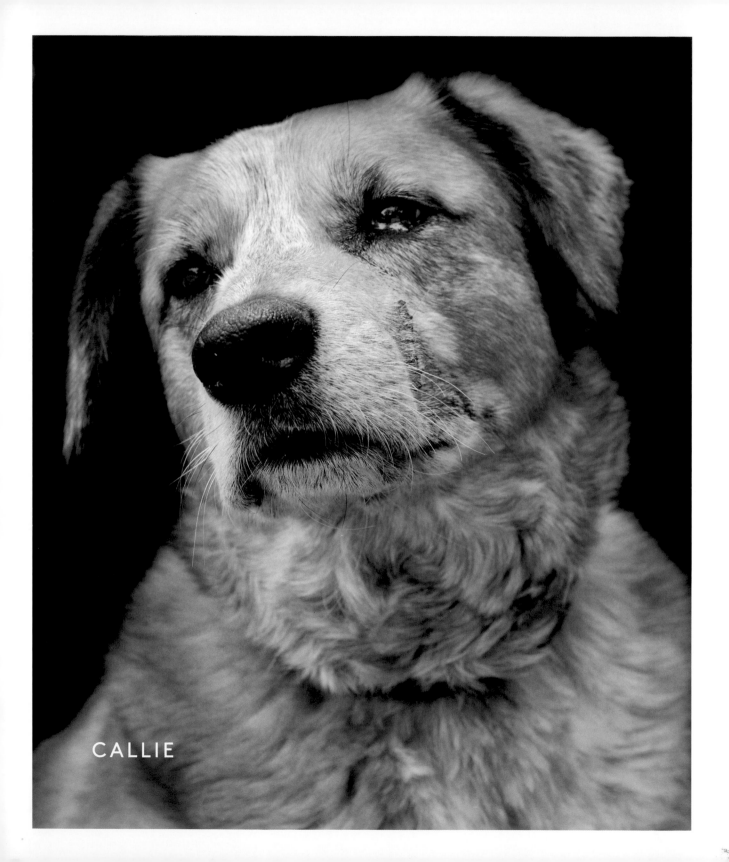

CALLIE

With cuts and scars on her face, Callie looked like she had been down a long and difficult road. She was shy and a little mistrustful of people, but, like most dogs, her instinct to enjoy human companionship eventually took over once she was shown affection.

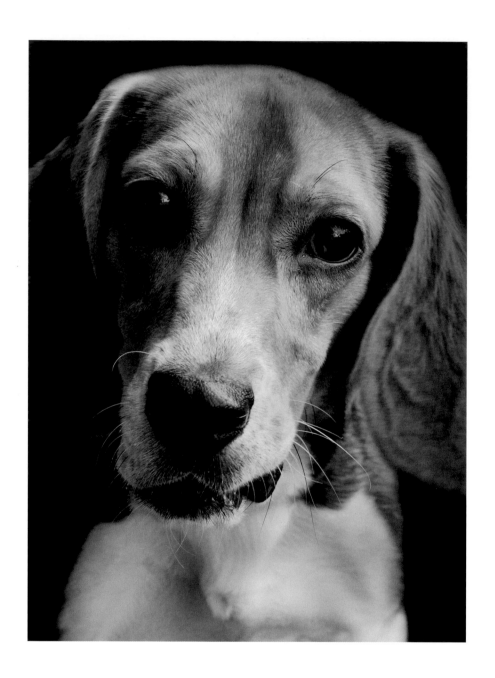

PRINCE

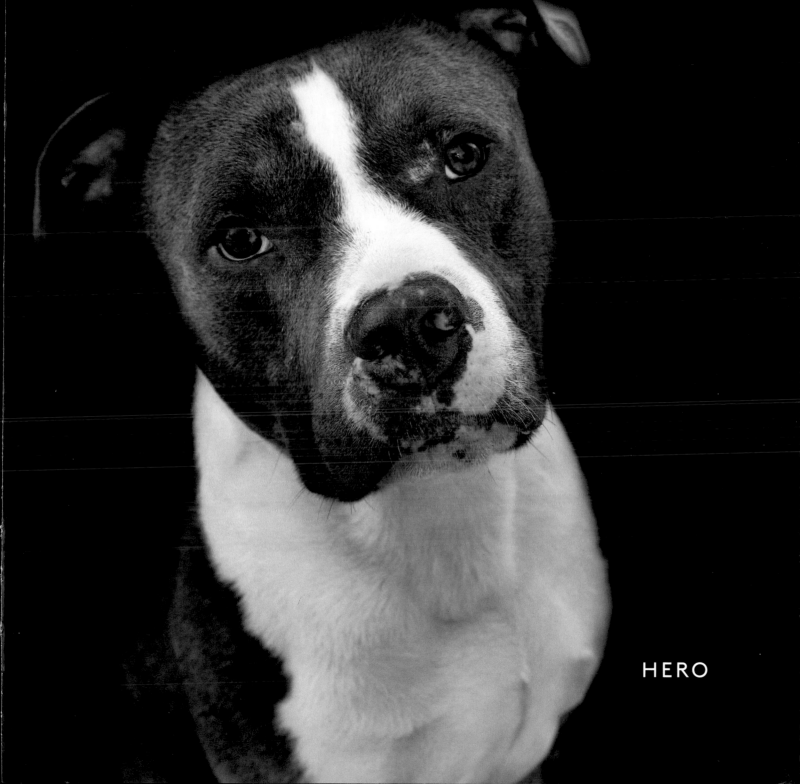

HERO

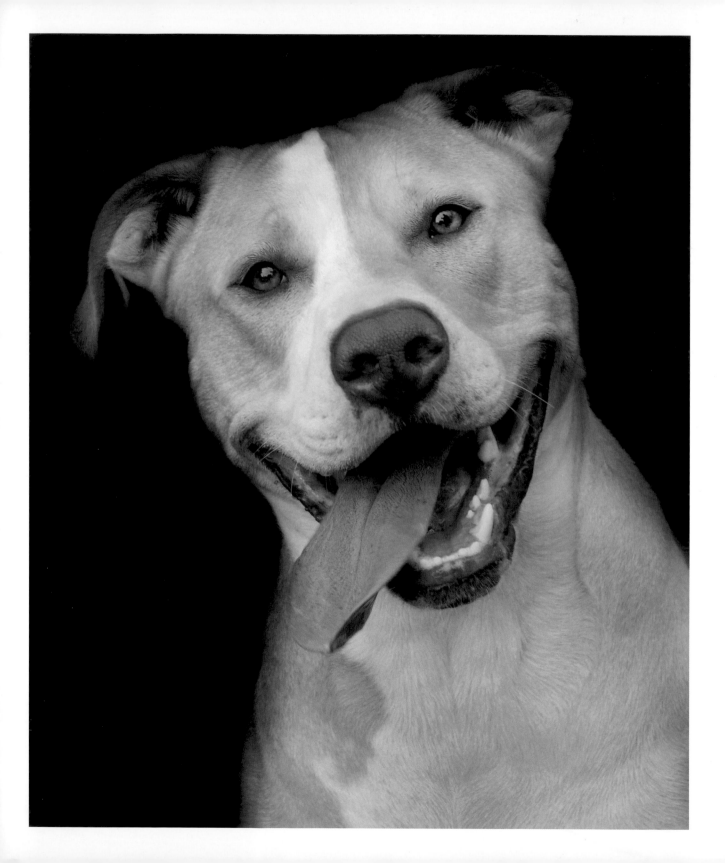

FLYNN

Purebred dogs are usually adopted very quickly,
but sadly, many, like Gypsy, end up being returned.
All dogs are bred to have very specific traits,
which are much stronger in pure breeds. Often
mixed-breed dogs make the best companions
because they combine the best of several breeds.
Gypsy eventually found a new home with a
family who appreciated her energetic character.

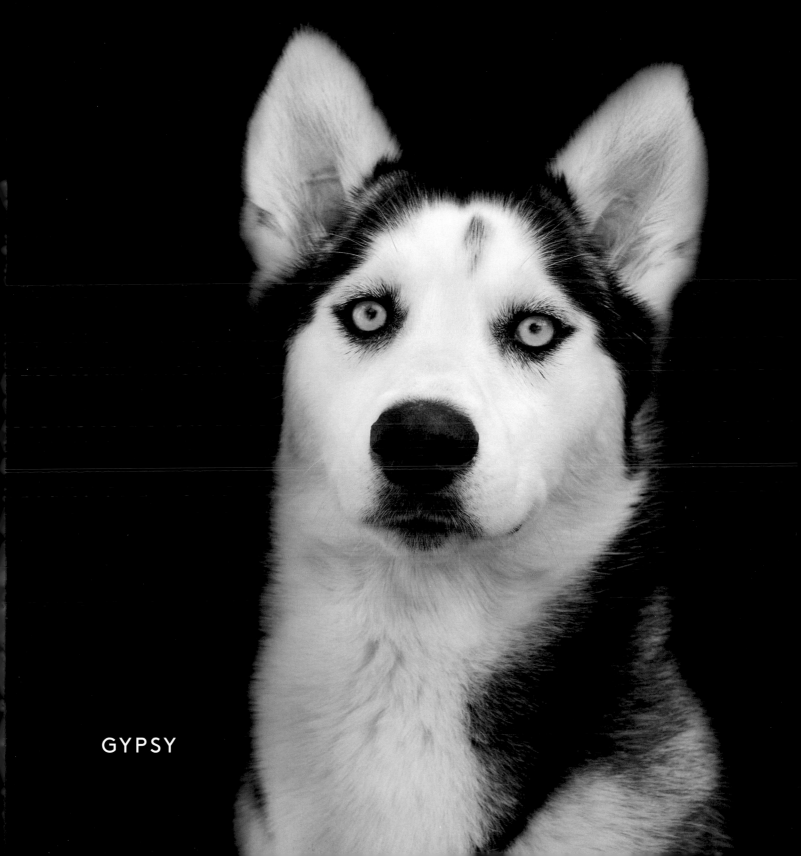

GYPSY

Biographies

BANDIT, *page 67*

Local animal control seized this Maltese mix from an elderly owner who was deemed unfit to provide proper care for animals. Bandit is the third dog that animal control officers have taken from this particular woman. He spent just three days in the shelter before being adopted into a new home.

CALLIE, *page 68*

A senior Australian shepherd mix, Callie was surrendered by her family of eleven years because she began showing aggression to the family's new baby. After about a month at the shelter, Callie was adopted by an older single woman with no children or other animals.

BINGLEY, *page 9*

Bingley, a pit bull mix, was seized by animal control officers during a drug bust, at which time he lost his hearing, probably due to auditory trauma from the sound of gunshots. The shelter taught Bingley hand signals and helped him to adjust to life without hearing. He became a staff favorite but waited at the shelter for four months before finding a new home. Finally, a family with two children fell in love with him and rose to the rewarding challenge of living with a deaf dog.

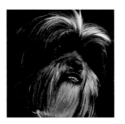

CHEWY, *page 21*

This shih tzu mix was surrendered to the shelter due to behavioral issues, having apparently bitten his owner several times. He was adopted into a new home after only about a week at the shelter. His new owner said he bites her occasionally too, but she doesn't mind. (Small dogs with behavior issues are much more likely to be placed than larger dogs, usually because the smaller breeds are thought to do less damage.)

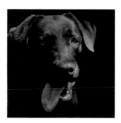

CHLOE, *page 56*

An energetic and loving eleven-month-old chocolate Lab mix, Chloe was surrendered to the shelter due to her owner's allergy problems. Because of her young age, desirable breed, and upbeat temperament, she was adopted within two days.

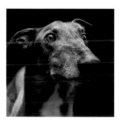

CODY, *page 25*

Two-year-old Cody was a racing greyhound who competed in twenty-one races at two different Florida tracks during his career. He was transferred to the shelter just weeks after his retirement and was adopted out within one month.

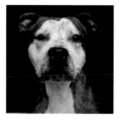

DUTCH, *page 42*

This playful, extremely energetic two-year-old pit bull was surrendered to the shelter because her family could not handle her energy level or provide the exercise that she needed. Dutch was adopted after just two weeks by a family who wanted an exuberant, active dog. Unfortunately, she was returned to the shelter just three months later because the family determined that they did not have enough time for her. Dutch went back up for adoption and was placed with a new couple about three weeks later.

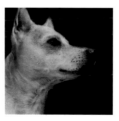

ELVIS, *page 61*

Found as a stray with a large laceration on one of his back legs, Elvis was picked up by animal control on a semiurban road. This plucky Chihuahua mix spent about a month at the shelter before finding his new home.

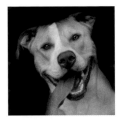

FLYNN, *page 72*

A large, playful juvenile pit bull/Lab mix, Flynn was found as a stray. Like most young, energetic dogs, Flynn struggled with shelter life. Despite daily walks with volunteers and playtime outside in the yard, he became hyperactive and anxious in his kennel. After being at the shelter for two months, he was finally adopted.

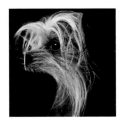

FOXTROT, *page 46*

A purebred Chinese crested, Foxtrot was surrendered to the shelter with three other Chinese crested dogs from the same home. Foxtrot's owner was a victim of domestic violence and was forced to leave her home without warning to enter into a victim relocation program. Foxtrot was the last of the four to be adopted but was at the shelter less than a month before going home.

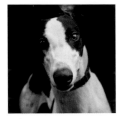

GABRIEL, *page 55*

A beautiful blue-coated greyhound, Gabriel raced only once in 2011 and came in last. He was considered too slow to be lucrative and was instantly retired. Gabriel was transferred to the shelter soon after his maiden race, then was adopted and returned twice. The second time he was brought back because he had suddenly become very ill; it was determined that he had meningitis. Gabriel was given a slim chance of survival, but the shelter was dedicated to treating him, and after extensive care, he beat the odds. At the time of publication, Gabriel had just celebrated his sixth birthday (by having a cheeseburger) and was still up for adoption.

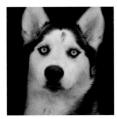

GYPSY, *page 75*

This young, striking purebred Siberian husky was surrendered with her brother Cosmos because their family's housing did not allow dogs. Gypsy was a smart, energetic, and talkative husky who was adopted out quickly but was returned later the same day. A few weeks later, she was adopted into her forever home.

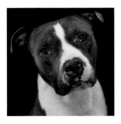

HERO, *page 71*

This young, gray-and-white pit bull was found curled up in a snowbank all alone on a cold day in early March. Hero was only one year old but very intelligent and interested in people. He was at the shelter for a month before being adopted.

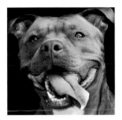

HOPE, *page 29*

Born with deformed front and back legs, Hope was adopted from animal control in New York City immediately before she was scheduled to be euthanized. Almost two **years** later, when her owner had to be unexpectedly hospitalized for a long period, Hope was surrendered again to a shelter. Deemed unadoptable, she was scheduled (for the second time in her life) to be euthanized but was reunited with her owner at the eleventh hour.

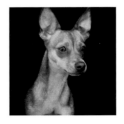

JADE, *page 52*

Little Jade was a purebred Chihuahua who was surrendered to the shelter because her owner had too many animals. She was not well socialized and was very fearful, but soon responded to the care and affection shown by staff and volunteers. Once deemed ready, she was officially put up for adoption and was adopted within hours.

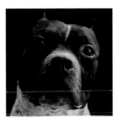

JUSTICE, *page 32*

This pit bull mix was surrendered to the shelter with his sister, Salt (see page 84), when the family's landlord decided that they were no longer welcome. After about one month, this goofy, lovable guy was adopted but returned to the shelter just a few days later (once again, due to landlord conflict). After his first brief adoption, he continued to live at the shelter for another two months before being adopted a second time—hopefully, for good.

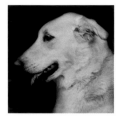

LADY, *page 59*

Elegant and loving, nine-year-old Lady was a white shepherd who was surrendered because she was having a hard time dealing with a busy household. Too many kids and other dogs made this quiet, good-natured senior nervous. After about two weeks in the shelter she was adopted into a new home without children or other pets.

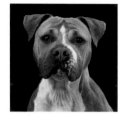

LORNA, *page 53*

Lorna was transferred from the city animal control shelter after she experienced medical complications from a spay surgery. She quickly became a staff favorite; an indiscriminate lover of dogs, cats, and people alike, this charming pit bull mix was adopted in less than a month.

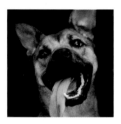

LAYLA, *page 15*

Smart, bubbly Layla was a young pit bull/shepherd mix surrendered to the shelter by a heartbroken owner whose financial problems had caused her to lose her home. Layla spent about two weeks in the shelter before being adopted by a young couple who were looking forward to having an active dog to visit the dog park and go jogging with.

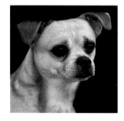

LUIGI, *page 26*

Luigi was a puggle, a highly desired "designer breed" that mixes purebred pugs with beagles. Surrendered because his family was moving, Luigi was put up for adoption almost immediately but soon started to show signs of serious aggression toward larger dogs. Fortunately, the shelter was able to transfer him to a large regional rescue organization with a specialized behavior treatment program, where he is learning to successfully socialize with other dogs.

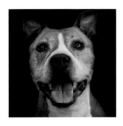

MATILDA, *page 13*

Senior pit bull Matilda was transferred from the city animal control shelter, whose kennels were full. Many lumps were discovered on the seven-year-old, and it was soon discovered that she had mast cell cancer, giving her only a few years to live. The shelter began searching for a hospice home for Matilda where she could live out her days happily. As weeks went by, though, sweet Matilda began to show serious signs of mental distress. Previously mild and friendly to all, Matilda began biting and pulling at her leash, showing minor aggression toward other dogs and becoming panicked in her kennel, until one day, as a staff member put it, she just snapped. As the shelter's behavior coordinator was taking her out of her kennel, Matilda became dangerously aggressive to a dog in a neighboring kennel. When the staff member tried to move her along, Matilda redirected the aggression at her and bit her in several areas of her body. A second incident occurred soon after, when a different staff member was trying to put her back in her kennel after playtime outside. Sadly, Matilda was no longer safe for adoption and had to be euthanized.

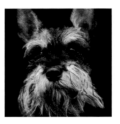

MIA, *page 12*

Wiggly, wagging little Mia was a purebred schnauzer who was surrendered because her family was losing its home. Mia was very affectionate and great with children. She was adopted within a few days.

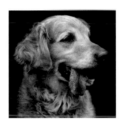

MOLLY, *page 10*

This sweet, superaffectionate senior golden retriever was separated from her owner of ten years after the woman was forced to move into elderly housing that did not allow pets. Molly was in the shelter about two weeks before being adopted by a man with disabilities and his family, who adore her.

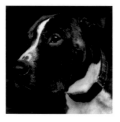

MORRISSEY, *page 39*

Originally found as a stray, Morrissey was transferred from the city animal control shelter to Providence Animal Rescue League, where he had developed a slight case of mange. The mange soon worsened dramatically, causing him to lose about a third of his fur. Treatment was begun, but the stress of shelter life often prevents dogs from being able to heal properly, and his skin neither improved nor further worsened. Morrissey won the hearts of staff and volunteers; money was raised for his continued mange treatment, and after several months at the shelter he was adopted by a family who didn't mind his patchy fur.

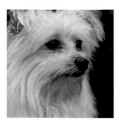

MUFFY VANDERBEER, *page 36*

A young woman bought this Pomeranian/bichon frise mix but did not want the work of house training her. She left the dog with her mother, who did not have time to care for a dog, so Muffy was surrendered to the shelter as a one-year-old. Tiny Muffy spent just six days at the shelter and now lives with a big, happy pit bull in her new home. The two are best friends.

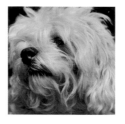

NALA, *page 60*

This shih tzu mix was surrendered to the shelter because her family did not have time for a dog. She is quite social and became friends with another shelter resident, a little terrier mix named Flynn. Nala and Flynn were adopted together!

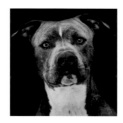

NANOOK, *page 35*

This stunning brindle pit bull mix (named by shelter staff after the dog in the 1987 film *The Lost Boys*) was found as a stray playing in the parking lot of the local electric company. He was untrained and badly behaved, but after evaluations, shelter staff soon saw a softer side to him and committed him to a strict training program. After several months of boot camp, he was adopted into a wonderful home.

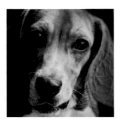

PRINCE, *page 70*

A purebred beagle, Prince was surrendered to the shelter because his owner did not have enough time to care for him. The owner's roommate had been sharing in Prince's care but had recently moved out. Prince was initially adopted within a few days but returned because of problems that arose from his separation anxiety and very vocal nature. He was adopted for the second time just hours after he was returned, by a lifelong beagle lover who understood and appreciated the quirks of the breed, such as frequent baying and talking.

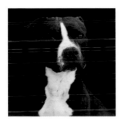

PYGMALION, *page 22*

This beautiful chocolate pit bull was brought to the shelter because his owner was homeless. Pyg was not used to children or strangers and found them to be threatening. Shelter staff and volunteers worked with him intensely for several months, hoping that they could better socialize him, but unfortunately, he was not able to unlearn his fears and was ultimately determined to be unsafe for placement. Pygmalion was euthanized.

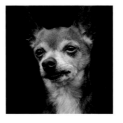

REMY, *page 47*

Remy was a senior Chihuahua who was surrendered to the shelter after his family moved to a new apartment that did not allow dogs. He did not adjust to shelter life well, so the shelter placed him in a foster home in hopes that he would be more at ease. After he settled in and became more comfortable, he began showing serious aggression toward people. His foster family worked with him extensively, trying to both understand and curb the aggressive behavior, but could find no pattern or predictable trigger. Remy was eventually deemed unsafe for adoption and was euthanized.

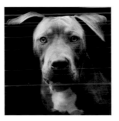

ROMAN, *page 49*

A statuesque Weimaraner/pit bull mix, Roman was already about forty pounds at just four months old. Rambunctious and growing bigger every day, he was surrendered to the shelter because his owner already had one dog and the landlord would not allow a second one. Roman was adopted after being at the shelter for about two weeks. Tragically, Roman was diagnosed with congestive heart failure after only three months in his new home and just weeks later was euthanized.

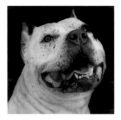

SALT, *page 45*

Surrendered along with her brother, Justice (see page 79), Salt lost her home after her owner's landlord changed his mind about allowing dogs, possibly because of their breed. Salt's cropped ears and stocky build made her look intimidating, but she was gentle and loving with both children and adults. Unfortunately, Salt had a history of minor animal aggression that was greatly exacerbated by the heightened sounds and stress of shelter life. She became extremely aggressive to other animals and was deemed unsafe for adoption. Salt was euthanized.

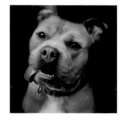

TEDDY, *page 23*

Teddy was picked up as a stray, and his goofy charm and lack of manners were immediately noticed by shelter staff. He constantly jumped on people and was very mouthy, which, given his large size, made potential adopters nervous. Volunteers and staff worked with him on basic obedience and socialization, and after several months he was finally adopted by a brother and sister who had seen his photo online. They were willing to put in the time needed to train Teddy and help him to thrive in a loving environment.

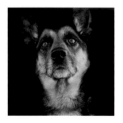

SOPHIA, *page 18*

Sophia was a purebred German shepherd who was found as a stray. This "lost dog" was claimed by her owner but then officially surrendered to the shelter because the owner maintained that he could no longer care for her. She was adopted about two weeks after being picked up by animal control.

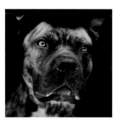

VINNY, *page 62*

Found as a stray, playing in the parking lot of a local boat manufacturer, Vinny was healthy and well groomed, leading the shelter to assume that an owner would soon claim him, but none did. He quickly became a staff favorite because he was so cheerful, loving, and funny, but after months of living in a kennel at the shelter, his behavior began to deteriorate. He was placed in a shelter enrichment program to try to ease his anxiety and aggression toward other dogs. After seven months in the shelter, Vinny was adopted by a local police officer.

Adoption Basics and Resources

I am interested in adopting a dog. Where do I start?

The best way to start is by looking on adoption sites like Petfinder.com, where you can look at photos and descriptions of adoptable animals in your area. This will also help you to determine what shelters or rescue groups are operating near you. Visiting their facilities in person is often the best way to see the most current selection of animals. You can call or look on the individual shelters' websites to find out their visiting hours.

What happens when I visit a shelter?

Generally, you will be directed into the kennel area, where you will see dogs who are available for adoption. Staff members or volunteers are almost always present to answer questions. If you see a dog whom you would like to meet one-on-one, there is usually a meet-and-greet room or outdoor play area that you go to with a staff member. There, you can get to know the dog a little bit better. It is imperative that you spend time with a dog outside of its kennel before deciding to adopt. Many dogs exhibit very different behavior in a kennel than they do outside, and it's impossible to get to know a dog's personality unless you interact with it directly.

They all look so sweet. How do I know what dog is right for my family?

It's always a good idea to research breeds before beginning a search for a new dog (one place to start is the American Kennel Club: www.akc.org), but keep in mind that many of the dogs you see in a shelter will be of mixed breed. It's extremely important to pick a dog who suits your lifestyle. Some are athletic and need lots of exercise, while others are content to sleep on the couch much of the day. Some shed a lot, and some shed less, while others do not shed at all. Some require lots of grooming and brushing, while dogs with shorter coats generally do not. Talk to the folks who work in the shelter—they know the dogs and can give you a good sense of a particular dog's needs—but meeting a dog one-on-one is the best way to know whether you have found the right match.

If I decide that I want to adopt a dog from a shelter, what will I have to do?

Procedures vary from place to place, but generally, you will fill out an application that will include basic information as well as questions about your prior and current pets. You will most likely be asked whether you rent or own your home, whether you have a fenced-in yard, whether or not you have ever owned a dog, what your work schedule is like, how many people live in your home, and what their ages are. Be honest and thorough; remember, these questions are not used to judge you, but rather to help shelter professionals determine whether your home and lifestyle are right for the dog that you are seeking to adopt.

Your application will be reviewed, and in some cases, the shelter may call your landlord or personal references before approving you for adoption.

Some organizations, particularly privately run rescues, require a home check before you can adopt a dog.

Once your application is approved, you will be asked to pay an adoption fee and a date will be set for you to come and take your dog home.

Do not expect to leave with a dog the same day. Although this does happen in some shelters, particularly overcrowded ones, it really is best to meet the dog a few times before making a final decision.

Should I bring my kids when I go to look at dogs?

Some shelters require that only adult family members come to a first meeting, but many do not. It may be OK to bring along children who are school-age or older. However, remember that even if your children find a dog appealing, it may not be truly the right dog for your family. Sometimes parents find that it's best to go without the kids at first, to narrow down the choices and to be able to tell the rest of the family what to expect at the shelter. If you do have children, however, it is absolutely crucial that they meet the dog before you bring it home.

How much does it cost to adopt a dog?

Adoption fees vary immensely, ranging from none at all to more than $500. Generally, shelters try to keep their adoption fees affordable while still covering the cost of spaying or neutering the animal, as well as providing vaccinations and general care. Keep in mind that the adoption fee also goes toward funding the many animals who require long-term or permanent care in the shelter.

Once you have your dog, you will have regular expenses, such as vet checkups, vaccinations, licensing fees, heartworm and flea prevention, and the cost of providing high-quality, nutritious food. The minimum yearly cost for responsible dog ownership is $600.

What should I buy to prepare for my new dog?

Plan on a bed, a brush, food and water bowls, toys, food, treats, an identification tag, and a leash and collar. Avoid metal collars, such as choke chains and prong collars. Instead, try a body harness or Gentle Leader to make leash walking easier.

What should I expect when I bring my new dog home?

Expect a period of transition. Introducing an animal into its new home is a major change and can be very stressful for all involved. A shelter dog is coming from a high-pressure environment and will need time to adjust. Try to bring the dog home on a Friday or a day when you can spend the next two to three days at home with minimal absence. Take the dog out to use the bathroom frequently and be patient.

Can't adopt a pet but want to make a difference in the lives of homeless animals?

- Consider volunteering at your local shelter. Not all volunteers work directly with animals, either! People with all kinds of skills are needed: photography, social media, marketing, design, fund-raising, and more.
- Donate money or supplies to a local animal rescue organization.
- Attend or participate in fund-raising events like walks, 5K runs, and silent auctions. Have fun and support a worthy cause.

National Adoption and Animal Welfare Resources

Petfinder.com is a wonderful resource loaded with tons of information about adopting.
www.petfinder.com/pet-adoption

The ASPCA has a website chock-full of adoption tips and information and also adopts animals out directly in the New York City area.
www.aspca.org/adopt

The American Humane Association has been on the forefront of protection for both children and animals since 1877 and is a leading authority on the human/animal bond.
www.americanhumane.org

The Humane Society of the United States is a leader in animal protection through legislation, reform, and emergency response.
www.humanesociety.org

Organizations Featured in this Book

Fast Friends:
http://www.helpinggreyhounds.org/

Handsome Dan's Rescue:
www.handsomedansrescue.org

North Kingstown Animal Shelter:
https://www.facebook.com/nkshelter

Providence Animal Rescue League:
www.parl.org

Reflections on Animal Rescue

The shelter system is both beautiful and haunting; it allows some dogs a new beginning, but just as quickly sets up others for failure. I no longer believe there are truly bad dogs in the world…only misunderstood, lost, and confused souls. I consider it my job to do everything in my power to get them a second chance.

Some days I am required to play God and fill out a sheet of paper describing why I feel a dog should not be placed for adoption. Later, as the dreaminess sets into his body, I cradle that dog in my lap. I kiss him and love him and tell him I am sorry and that he is such a good boy. Although I cannot save this dog, I'll be damned if he leaves the world feeling unloved. I can make sure he knows that his life was valued and appreciated. Other days I am sure I look like a lunatic: sobbing and laughing, because a dog I spent months pouring my heart and mind into just found somebody who understands and loves her as much as I do. Every single day is overwhelming in an entirely different way.

I've realized that losing dogs is a part of my job that I must accept so I can continue helping others. On tough days, I look at all of the dogs who have found amazing homes and use that as a gentle reminder to myself that what I do matters…even if only to one or two dogs, every once in a while. It's not about saving them all—it's about giving them fair shots and never losing compassion for these incredible and selfless creatures.

— BETHANY NASSEF, Dog coordinator, Providence Animal Rescue League

Animal rescue has always been my passion, and I've volunteered for most of my adult life. However, until the last few years I've never allowed myself to volunteer in a shelter; being around animals who weren't going to make it just seemed to be more than I could deal with. This all changed a few years ago when I learned of a pit bull who was nearly out of options at a municipal shelter. Foster homes had fallen through, no adopters were coming forward, and life in the kennel was overwhelming him. A friend of mine who was volunteering at the shelter began desperately reaching out to save this dog. With great hesitation, I agreed to go to the shelter to work with him several times a week. He needed help with basic skills such as sitting and taking treats gently, but he primarily just needed time outside his kennel. The day I walked into that kennel area and looked into the faces of the dogs—some hopeful, some scared, some barking a "back-off" warning—I knew my life would never be the same.

I had convinced myself I couldn't volunteer in a shelter where animals were euthanized. I was wrong. It's never easy, but I can do it. I've now spent countless hours with and fallen in love with many dogs who didn't make it. However, I have also felt limitless joy when a scared, broken dog has trusted me for the first time with a tentative lick on my hand, a lean against my leg. As they trust me, they venture out to trust others and in many cases find themselves in a new home with a new life. Although I cannot save them all, I can make whatever time I spend with each one of them matter.

— TRISHA TORRES, Owner of Aspects, Inc., and board member of Handsome Dan's Rescue

Personal satisfaction comes to me from knowing that I endeavor to speak for those who cannot, to show patience and understanding to animals who have been surrendered or dumped on the streets, and to take the time to help those animals feel trust and love again.

To say I've had my heart broken would be an understatement. It's true—this work can really break you down: picking up someone's pet who was hit by a car, breaking the news to the family of a dog who was struck by a train, having to make the choice to put down a sick cat while that animal is looking you right in the soul with the kindest eyes you've ever seen.

I've had to euthanize a dog whom I loved and spent months trying to rehabilitate, after needing to face that he was a danger to society. I will never forget those eyes as I pinned him in the corner of the kennel when the vet came in. He fought me; he was fighting for his life. I try to think of how I made his life the best I could. He was loved by me, and I hope he knew that.

Doubt and guilt are among the emotions I feel routinely. But there is some light at the end of this tunnel, and it's beautiful, and it is what keeps me going—what helps me sleep at night and what wakes me up to do the same thing all over again another day. I think of the hundreds of animals I have saved, the hundreds of animals whom I've loved with all my heart. Each and every one of them, each an individual, has planted a seed in my heart, and it makes me grow stronger each and every day.

— **HOLLY DUFFANY,** Animal control officer,
North Kingstown Animal Shelter

I was a foster mom for an all-breed rescue when asked if I could take Lady, an incontinent senior pit bull who had been pulled from the largest homeless shelter in our state. Not many foster homes at that time were open to accepting pit bulls. Into my life walked Lady, and everything changed. Had I known then what I do now, Lady would have never left my home. I never knew how old this darling was, but her amazing adoptive mama told folks she was thirteen for the last several years of her life.

Lady came back to see me last year, her old body losing its long and valiant fight against cancer. No more surgeries, no more pain—just love and whatever she wanted to eat and wherever she wanted to go for the time she had left. I said my good-byes to her, so many years after she had left my home the last time. When Lady was adopted I didn't really understand the mark she had left on my heart or that our time together would set a course for the way I live my life. She had won me over to a type of dog to which I had not given much thought previously. Had I not met Lady, my life most definitely would look very different than it does now.

Lady passed away a few months ago. I owe so much to that beautiful black-and-white dog. She gently directed me toward my life's path and remains ever present in my heart through each dog we save.

— **HEATHER GUTSHALL,** Founder,
Handsome Dan's Rescue

ACKNOWLEDGMENTS

To the four women who made this book possible by
coordinating schedules, keeping notes, wrangling dogs, dangling treats,
and freezing in the play yards with me, thank you: Trisha Torres,
Connie Bolduc, Bethany Nassef, and Holly Duffany. Also Heather Gutshall,
Carmine DiCenso, Marylou Hecht, Sharron Thomas, Beth Butler,
Amy Duskiewicz, and all of the staff and volunteers at Providence Animal
Rescue League, Handsome Dan's Rescue, and Fast Friends.

Immense gratitude, love, and respect to my agent and friend
Joan Brookbank. Thank you for your loyalty, expertise, and kindness.

Thank you to my wonderful editor, Sara Stemen, for always finding the
right words. Also to Jennifer Lippert, Diane Levinson, Paul Wagner,
Mia Johnson, Janet Behning, Andrea Chlad, and everyone at
Princeton Architectural Press who believed in this project and made all of
the fragmented pieces come together to create something beautiful.

I am ever grateful for my daughter, Agatha,
who brings constant love and light into my life.